TYPE & COLOUR

A Handbook of Creative Combinations

BY
ALTON COOK
&
ROBERT FLEURY

COLUMBUS BOOKS

Copyright c 1989 by Rockport
Publishers, Inc.

First published in the United States
of America by:
Rockport Publishers, Inc.
P.O. Box 396
5 Smith Street
Rockport, Massachusetts 01966
Telephone: (508) 546-9590
Telex: 5106019284
Fax: 508 546-7141
ISBN: 0-935603-19-0

Distributed in the U.S.
by: North Light Books, an
imprint of F & W Publications
1507 Dana Avenue
Cincinnati, Ohio 45207
Telephone: (513) 531-2222
Fax: 513 531-4744

First Canadian edition 1989,
published by Rockport
Publishers Inc. for
Firefly Books Ltd.
250 Sparks Ave.
Willowdale, Ontario
M2H 2S4 Canada
Telephone: (416) 499-8412
Fax: 416 499-8313

First published in Great Britain by:
Columbus Books, Ltd.
19-23 Ludgate Hill
London, England EC4M 7PD
Telephone: 01-248-4444
Fax: 01-248-3357
ISBN: 0-86287-961-2

First Taiwan edition 1989,
published by Rockport
Publishers, Inc. for
Chin Shan Book & Stationary Co.
89-6 Chungshan N. Rd.
Sec 2 Taipei, 10419 Taiwan
Telephone: 5515700
Fax: 2-536-5510

First Philippine edition 1989,
published by Rockport Publishers, Inc.
for National Bookstore
701 Rizal Avenue
Manila, Philippines
Telephone: 49-43-06
Telex: 27890 NBS PH

First Singapore edition 1989,
published by Rockport
Publishers, Inc. for
Page One
The Designers Bookshop Pte Ltd
6 Raffles Boulevard
#03-128 Marina Square
Singapore 1030
Telephone: 3390288
Fax: 65-339-9828

First Hong Kong edition 1989,
published by Rockport
Publishers, Inc. for
Keng Seng Trading & Co.
SWN P.O. Box 33723
Hong Kong
Telephone: 5-455008
Telex: 64 P20 KSHK HX
Fax: 5-414025

First Korean edition 1989,
published by Rockport
Publishers, Inc. for
Chongno Book Center Co., Ltd.
CPO Box 3973
Seoul, Korea
Telephone: 732-2331
Telex: 29926 CHONGBK
Fax: 822-732-9223

DEDICATION

To EDITH WALKER, a high school art teacher whose patience and genius came at just the right time in a young artist's life.

And to JEREMY ("The Wiz") JOHN, a type director and mentor who will be sorely missed.

ACKNOWLEDGEMENTS

Our effort here is the work of a great many people... in fact, some who may not have even realized their contributions at the time. And we want to say that we appreciate and value their help.

First, thanks to those professionals whose assistance and ideas went a long way to making TYPE & COLOR the fine piece of work it is:

ALLAN HALEY, for his essay on the fine art of
 fine type
GEORGE CAWTHORN, for his insightful essay
 and consultation on color theory
ALAN PECKOLICK, for his synthesis of color
 and type design
SCOTT ROSS, whose illustrations help to add
 color to our introduction
SKIP GANDY and his photographic staff
ROBERT MATSON and his team at We Copy

And thanks again to the designers and their companies for the splendid work we've been allowed to display here. Their credits accompany their work.

Finally, nobody does a good job at the office without forebearance and encouragement on the home front. Therefore, we'd be remiss in not expressing our gratitude for the help we've received from our families and our good friends, as we worked to invent this book.

STAFF & CONTRIBUTORS

EDITOR	ROBERT FLEURY
DESIGNER/ART DIRECTOR	ALTON COOK
ART ASSISTANT	HEATHER K. MANNING
COLOR CONSULTANTS	GEORGE CAWTHORN
	ROBERT TERRI
PHOTOGRAPHY	GANDY PHOTOGRAPHY
	TAMPA, FLORIDA
TYPESETTING	CONWAY TYPOGRAPHERS
	TAMPA, FLORIDA

COVER PHOTO: ROBERT BOVA
ILLUSTRATIONS: SCOTT ROSS

Contents

Harmonies between
typography and color offer
us limitless opportunity
to bring vitality, interest and
variety to the printed
message.

Introduction

WHAT IS COLOR, ANYWAY?

Color is a curious thing. It can be measured, quantified and classified in the laboratory; it can be turned into a fine engineering tool or recording device; it can help us measure a molecule or a galaxy, but to the human eye, color has always been much more than just a case of "this frequency or that". Color is information...instantaneous, reliable and exact. It's communication, rich, subtle and complete. In fact, it's about the only true language we have other than music that doesn't require words.

And what a language it is. Why does red mean "STOP!"? Perhaps because it reminds us of FIRE. ...DANGER! Or maybe just because in a world of tree-lined avenues, red was easy to see. How visible, by comparison, are the red stoplights against the Las Vegas night? Fire trucks all used to be painted red, until chartreuse was deemed more visible. And since visibility is really important in an emergency vehicle, it's hard to argue such a point.

Identification. Visibility. Communication. Three jobs color does better and more quickly than anything else. But...

Color is nothing but light of a particular wave length, or frequency. The higher the frequency (the shorter the wave), the more energetic the light. Red light carries less energy; blue light, more. X-rays and gamma rays even more still. But in the narrow sense, they're all colors. Color is at the heart of light, and light, simply put, is what you see.

Like light, color has a form that can be described by physics and mathematics, but it exists also in a far more subtle manifestation...that of perception.

Light is the messenger; color is the message, the internal variation within the arriving stream of energy...in how much energy each photon carries. As these particles arrive with various levels of energy, they are also carrying information. This is the language of light. This is what we see as color.

And in terms of color, what we see is a great deal more than what we get. Light arrives in literally millions of colors, but our brains are organized to deal with only four of them. The millions of colors we think we see are really only a blend of red,

blue, green and yellow. That's all our optic hardware can deal with. Though the actual colors used are different, all printing, and in fact motion pictures and television, all depend on an analogous system of building a rainbow from only four colors. We really do live in a four-color world, and this simple, if surprising, point is exactly what a large part of this book is all about.

About 1450, the printmaking enterprises of Johann Gutenberg and others created a revolution in communications unmatched until the introduction of television. Movable type gave us countless Bibles, dictionaries, almanacs, road maps, math books, newspapers and so on. More recently, television has given us more of the same, only it now comes to us faster and cheaper, and it's more fun to look at. The revolutionary effect of TV was probably similar to that experienced in 15th Century Europe when publishing was being invented.

While, thanks to TV, we may be becoming less "literate", we are at the same time becoming more design-conscious and, consequently, more communication-sophisticated , if only because the visual message and the design requirements that go with it are now so much greater a part of our world. Communication may need "words", but we are learning that a word is more than just a string of letters that we've seen before.

Today, nobody serious about mass communications would dare ignore the importance of two questions... What's the Good Word? and What Color Is It?

We now have in our drawing-board arsenal the capability to deliver our message in whole spectra, entire rainbows, veritable riots of glorious color.

But legibility must come first. If they can't read it, you've failed. If they CAN read it, but won't, you're no better off. If your message is legible, but lost in the clutter of the competiton, you still lose. Not all colors are easy to read; in fact, some can be downright hard on the eyes. And when legibility suffers, type's whole reason-to-be is compromised.

The safe way is, of course, to stick with Helvetica in black on a white background. But that's not right. We *WANT* to use color, and use it effectively. We want it to increase our client's sales, visibility and influence; yet we also want it to turn out as a great piece of commercial art if only for our own professional satisfaction. If it's in print, it's frequently in color. If it's on TV, it's almost always in color. So the designing mass-communicator had better know how to use color and type effectively, and into the bargain, know how to put these two birds together and make them sing.

Taste is one thing, but color selection in commercial art is quite another. Where your client's sales are concerned, the wrong colors can kill. It's up to you to select color combinations that are: arresting, appealing, evocative, and effective. A tall order, but now there's a simple way to manage all the factors, to reduce the guesswork, to arrive quickly at the right answer. Test it with your own eye.

SUBJECTIVE COLOR

Almost everybody has had, at one time or another, a "favorite" color. This is usually expressed during childhood, but though a more adult version might be along the lines of "This color goes well with that", color preferences tend to stay with us pretty much throughout our lives.

Now, in trying to appeal to a large market segment through color, you quickly become aware how much is riding on your ability to read the public's mind. Of course, some guesswork will always be part of the job, but there are a few things you can do to help yourself arrive at an answer that will sell the product, look good, and make you look good. Remember, color is a subjective thing because for each of us the past is a different set of memories, and memory is jogged by color, just as it is by an old song, a familiar voice or maybe the smell of burning leaves. This, it seems, would only make your job harder, but it needn't be that way.

By and large, people tend to like the same broad categories of things. Sunny days, fireworks, cool clear streams, festivals, fur parkas...well, you get the idea. And that's where a little creative connection-making on your part will help get you past the first, most critical part of putting color to work for you. For example, if you're working on a label for a bottler of natural mineral water, what color family comes first to mind? Or what about a fire extinguisher ad? See the difference? The guidelines are usually there, but the creativity has to come from you.

The purpose of this book is to help you take the creative concept through production; but remember, color in marketing is a subjective thing. It's a tool to help the talented artist speak to the market, in words of no language that add power and richness to any language. This is why it is so important to be able to work quickly and confidently with color, to understand and use typography's disciplines and possibilities, and to put the two together. This is the foundation, of all design.

Technically, color theory must remain just that, only theory, until sound design principles, from A to Z, are understood and applied.

More than just a reference manual,
this is a hands-on laboratory where creative color type combinations
can readily be invented, tested and refined.

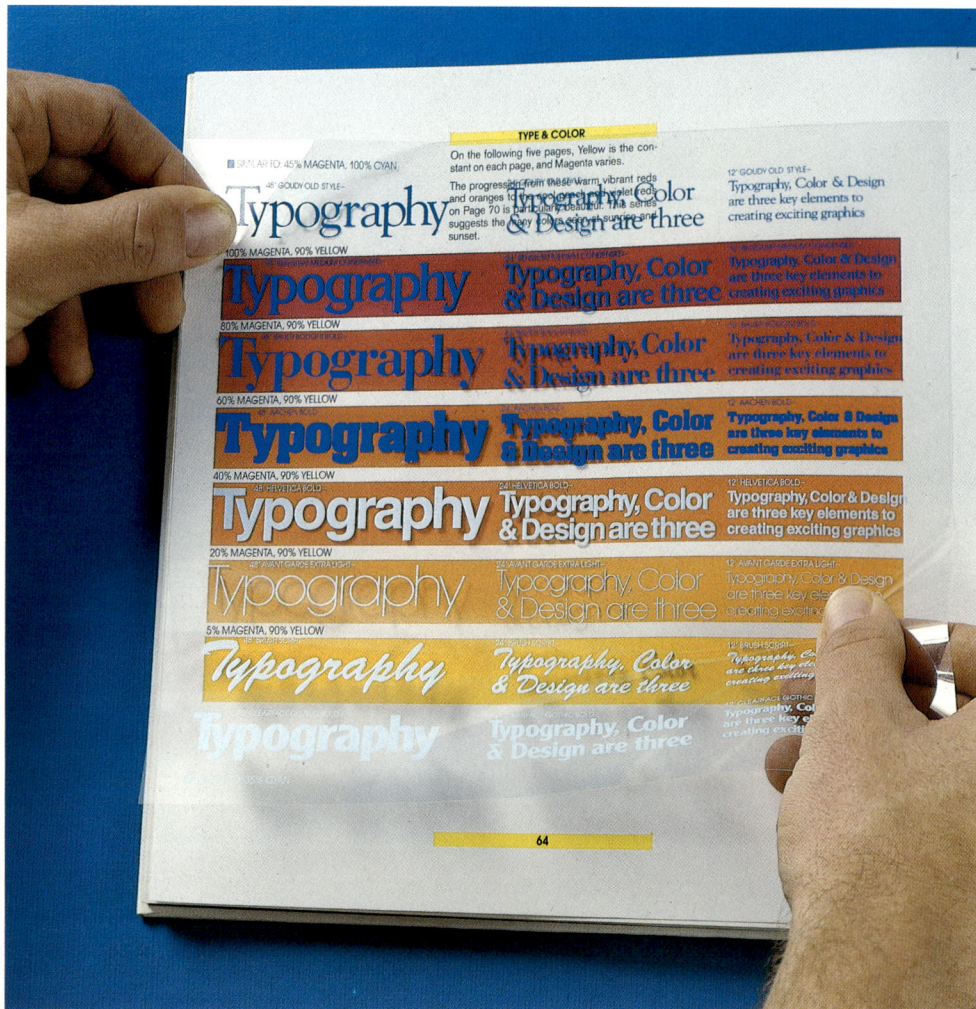

How to Use this Book

TYPE & COLOR, as you are by now aware, is both a book and a tool. While it is neatly divided into the book part and the tool part, (the Color Selector with Acetate Type Overlays), each section is an integral part of a single unified designers handbook.

The first fifty pages cover the theories and techniques necessary to effective use of color and typography. Use these sections as reference, since much of the material contained in the three essays and in Great Combinations, and Theories & Ideas pertains directly to how efficiently you'll be able to use the Color Selector.

The Color Selector, beginning on page 52, is the hard-working part of the book. This consists of 100 pages of carefully selected color bands...600 in all...and a package of 10 clear type chart overlays. Each overlay is printed with eight typefaces in three sizes, and each acetate is printed in two different colors. In all there are 18 colors, plus black and white, and a six-level gray scale. By placing an acetate over any of the 600 color bands, you can see instantly how a particular type/color combination will look,

and, using the gray scale, you can add an appropriate amount of black. For this reason, none of the color bands includes a density for black ink.

As you can see, this selector is based on four-color process rather than any particular ink-matching system. The ink "recipes" are called out on each color to make creating combinations quicker and simpler. Naturally, there are more than 600 colors in our world to choose from, and we have had to select from the entire visible spectrum this relatively small number for reasons of space. But even so, these pages and overlays allow for more than 800,000 different color combinations, type faces and sizes.

In addition, the acetate overlays work very well with whatever color-matching system you wish to use. This alone should allow you a virtually unlimited range of combinations. Likewise, we encourage you to bring your own actual photography and artwork into the equation. In short, no matter what your design requirements, TYPE & COLOR should be able to make arriving at the best solution a simpler, faster, more efficient process.

3 ur'

Typography, Color & Design
are three key elements
to creating effective graphics.

Typography, Color

type

& Color

@

ALLAN HALEY

ON

Effective Typography

Good typography is a clean window. Writers, clients, bosses, provide the landscape — the view; but a window of communication separates this view from the reader. It is the graphic communicator's job (our job) to provide clean windows. Windows which do not cloud or distort the view; windows that let the message shine through.

Good typography is not pretty design. Pretty design calls attention to the window, not the view. Pretty design is the designer's "fingerprints" left on the window of communication. Good typographic communication is not pretty — it is smart. It helps the reader assimilate and understand the message.

Type is to read. And in the competition for the reader's time and attention, the graphic communication that is the most inviting, and easiest to use, will be judged to be "best," "most useful," and "most valuable."

The goal of all printed communications should be "reader-friendly typography." The easiest way to do this is to consider the needs of the end-user. The best typography is always arranged and tailored to the needs of the reader.

There are relatively few criteria for creating user-friendly typography. Oh, there are probably hundreds of typographic rules and guidelines which could be memorized and followed blindly; but graphic designers needn't clutter their minds with such trivia. Really, there are only five things that a typographic communicator needs to be aware of:

Visual Relationship
Clear Structure
Segmentation
Inviting Doors
Noticeability

VISUAL RELATIONSHIP

Information must be analyzed and ranked in order of significance before it can be absorbed and applied. Such work demands time, effort and concentration on the part of the reader. Those of us who use and specify type can help this process by identifying the relative importance of the various elements in a piece of graphic communication by the way type is handled. The type's size, boldness, placement on the page, etc. can easily establish relationships of rank and importance. Two benefits are the result of handling type logically and with just a little imagination: informational relationships

Alphabet designed by Lisa Salvino.
Reprinted with permission of U&lc
(International Journal of Typographics).
Initial cap designs by Carol Greger.

are understood at first glance, and the communication looks livelier and more inviting. The bottom line? Good typography.

CLEAR STRUCTURE

It's no fun being lost in a multi-page document. Not knowing how long it is going to take to find one's way is even worse. Typographic arrangement that makes sections, sub-points, or chapters, etc. discernible at first glance is always the best. Logical typeface changes, reference marks, boxed material, a systematic format, and the intelligent use of color, all contribute to reader confidence and understanding.

SEGMENTATION

Imagine how difficult it would be if a dictionary were set as running copy. (All the information would still be there, but there would be no typographic clues, or segmentation, to help the reader.) Without the clues, dictionaries would probably not be used very much. All forms of typographic presentation (not just dictionaries) can benefit from clues and segmentation. If included as part of the design process through the simple handling of typeface, typographic elements—and color, the end result will be that individual components can be easily presented, and accepted, as "bite-size chunks."

"Graphic communicators are some of the most vital links in the communications chain. We are the link between the provider and the receiver of information."

INVITING DOORS

Headlines, sub-heads, the use of white space, and yes, even the use of color, can provide inviting doors of entry. These elements can easily call attention to the text copy, and more important, encourage its reading.

NOTICEABILITY

Traffic signs are large enough to be seen from a distance, located in an expected place, and recognizable in shape and color. Like driving down a road, the reading of a printed document or brochure is improved through the proper use of typographic traffic signs. New signs are revealed as we reach them — as copy is read and pages turned. Printed signposts are obviously best when put where readers expect them, and created so readers can easily recognize them. Handled well, these typographic signs aid both readability and understanding.

WHY GOOD TYPE?

Why is good typographic communication important? Two reasons: because you have something to say, or because someone else has something to say — and you want to keep your job.

BECAUSE YOU HAVE SOMETHING TO SAY

Whether you are creating a poster, letterhead, or capabilities statement, it just makes good sense to produce as good typography as you can. Compare your personal graphic design to the task of asking your boss, or a client, for more money. Would you want to communicate this message in any but the best possible way? Well, personal graphics is asking for money. They advertise your work — your ability.

It is just common sense, then, to want to produce the best typography in your graphic design. In day-to-day life we almost always try to communicate effectively. Most of us want to be heard, listened to, and to receive positive response. We don't always succeed, but "good enough" is rarely our goal. So it should be with graphic communication — "good enough" never is.

BECAUSE SOMEONE ELSE HAS SOMETHING TO SAY

Graphic communicators are some of the most vital links in the communications chain. We are the link between the provider and the receiver of information. Newsletters are meant to be read, not just take up space on our desks. Brochures are supposed to provide information and encourage action. Even lowly parts lists and directories are meant to be effective communicators.

Your financial success is directly linked to your graphic communications skills. Pretty design that does not sell the product, provide the information, or direct the reader, is not good design — and clients only reward good design. Repeat business, and ultimately new business, is predicated on your ability to produce good graphic design.

THE IMPORTANCE OF BEAUTY

Where do the concepts of "pleasing design" and "esthetics" come in? Nowhere — and everywhere. If good typography means cosmetic prettification, then nowhere. If it means the logical and straightforward presentation of information, then everywhere. Clearly, it is important to have an attractive typographic product; but looking pretty is not the prime purpose of typographic communication. It is a by-product of the prime purpose, and that is providing clear windows of communication.

GEORGE CAWTHORN

ON

Color: Interactions and Contrasts

Line and shape are the two primary elements constituting the body of design. Color, the "soul" of design, is deeply rooted in human emotions. Historically, color has always been used in many ways: Practically, for distinction, identification, and designation of rank or status; symbolically, to reflect love, danger, peace, truth, purity, evil, and death for example; and finally, to give direction, as in modern traffic lights, stop signs and other signals. Skilled designers routinely use color in controlled ways to create visual conditions of unification, differentiation, sequence and mood. Feelings can be generated that are calm or excited, bold or passive, sad or joyous, masculine or feminine. And as well, spatial effects… closed-in and compressed, or light, open and airy, can be created to suit the designer's needs.

Modern graphic designers and artists have become very concerned with color and its relationship to the differentiation or separation between background and motif. The ability of color to evoke unique and unexpected responses, particularly where color typography relates to a background, photograph or illustration, will not be lost on the alert designer.

Of primary importance is the fact that we do not experience color as an isolated event or sensation. No color is an island in our visual field, and colors only exist in direct relationship to each other and a given light source.

The conventional concept that all color is broken into the three primary colors (red, yellow and blue) does not allow for the problems faced in either four-color process or multi-color printing. The ink colors: black, cyan, magenta, and yellow, are the four colors always available…with the paper, usually white, adding the fifth color. The basic problem is that we cannot add white or black to a color without reducing its color strength, or chroma, and the brightness of the white base under all the colors of ink is often limited by the choice of the paper to be used in the job. In most cases, the best paper for this purpose, the whitest, least absorbent coated stock is also the most expensive, adding one more color to the equation…the color of money.

Color is technically described in four

basic ways: Chroma; how intense the color is…its strength. Value; how light or dark the color is. Hue; red, yellow, orange, blue, green or violet…and Temperature; is it a "warm" color or a "cool" one? In theory, three hues…red, orange and yellow…are warm, and three are cool…violet, blue and green.

These six cardinal hues compose the entire spectrum of visible light. Within each hue there is a warm side and a cool side. For example, although green is considered a cool color, yellow-green is warmer than blue-green. Likewise, while red is considered a warm color, red-violet is cool compared to red-orange.

The fluctuations between warm and cool within a given hue, and all the variations in temperature between hues…a warm blue opposed to a cool yellow, for instance…are seemingly endless. One of the most overlooked and misunderstood aspects of the interaction of color is the importance of temperature modulation and opposition. Contrary to popular perception, red and green are not the two most contrasting colors in terms of temperature. This distinction goes to another pair, red-orange and blue-green. In a theoretical color wheel configuration following the sequence of red, orange, yellow, green, blue and violet, and the sequence of temperature fluctuation of each hue from its warm to its cool side, a direct opposition, or temperature polarity, exists between blue-green and red-orange. Likewise, a relative temperature neutrality exists between blue-violet and yellow-orange, as well as between red-violet and yellow-green. The accompanying diagram illustrates this very well. The variation in the contrast of colors can also be greatly influenced by the

mass of one color relative to that of another. For example, if we have two pages measuring ten inches on a side and facing each other in a book, and having equally intense yellow backgrounds, then a thin red line running down the center of the page on the right will not look as red as a three-inch square of the same red color placed in the center of the left-hand page. In fact, the three-inch red square will appear to be brighter, and also lighter, than the thin red line. A similar effect is seen if for a moment we imagine another ten-inch square yellow page with a 1/8-inch red square at its center. As we watch, the red square slowly begins to enlarge, ultimately to a point where it's reasonable to ask whether we're seeing a yellow page with a red square in it…or perhaps a red page with a very fat yellow border. And also, how has the interaction between these two colors changed? Does the red now look lighter because of its increased mass…and how has the yellow changed in relation to the red square due to its own diminished mass?

Variation in contrast becomes very noticeable when one color of a medium value and chroma crosses over and through several colors of varying values and chromae. Against a color of low value…a dark color…the color of medium value will appear light, and as it crosses a color of higher value, the same color will darken. Overlaid on a color of equal value, this medium color will appear neither particularly light nor dark, but will be distinguishable only by its differing hue and temperature. This is where the effect of vibrating colors originates. The more closely two colors approach in value and chroma, and the more opposite they become in hue and

temperature, the more pronounced becomes the famous "vibrating" color phenomenon. This is because the only factors the eye can distinguish between two colors of equal value and chroma are hue and temperature, and as these differences become more pronounced, the interaction between the colors increases.

Subtractive and additive interaction between colors is directly linked to fatigue or over-stimulation of the retina. When, for example, a three-inch square of very bright blue is placed in the center of a ten-inch square of very bright orange, the additive and subtractive effects can be observed as follows: The orange square will look more orange with the blue square in the middle than it will without, and the blue square will look more blue for being in the midst of the orange field. Also, where the two colors meet, the blue will subtract itself from the orange and at the same time add its complement (in this case, orange to orange), thus intensifying the already strong contrast. The reverse happens between the orange and the blue, with the orange subtracting itself and adding its complement, blue, to the blue. The result is a distinct glow between colors of medium value and high chroma, but at the same time very interesting and subtle effects can be achieved between colors in the darker, less intense range if careful attention is paid to this principle. This additive/subtractive effect can also be experienced if we stare directly at the blue square in the orange field for a few moments, and then quickly interpose into our gaze a light gray background and continue to stare at the same point. A completely reversed color image will appear on the light gray paper…a large blue square with a small orange square at its

center. Each color in this afterimage is the perfect complement of the actual colors we were just looking at.

Frequently designers are faced with the problem of selecting several colors that work well together in harmony, and do not compete among themselves for attention. Harmonious color groupings or families can be achieved through the use of a common undertone to relate colors of various hues to each other. For instance, in four-color process, a common violet undertone of 20% Magenta and 20% Cyan could be established for a grouping of colors. A red, green, yellow or blue could be chosen and, though none of these four colors comes even close to looking like violet, if they all contain at least 20% Magenta and 20% Cyan, then the violet undertone will unite these colors as a family. The underlying principle is that the more in common colors have with each other, the less they will contrast, and the less they share in common, the more they will contrast.

In recent years many new approaches to color have surfaced in fashion, art, graphics and architecture, and in the future we may expect even more creative and personalized applications to emerge. Designers that develop a greater understanding and appreciation of the interactions of color, with the attendant complexities and subtleties, will have a tremendous advantage in planning color schemes, and will enjoy the confidence to explore color in bold new ways…a confidence that their color choices are based on solid principles rather than personal preference alone. A sense of taste is one thing, but it is understanding how and why colors interact that gives us the control to put our instincts to work.

"Designers that develop a greater understanding and appreciation of the interactions of color…will have a tremendous advantage in planning color schemes."

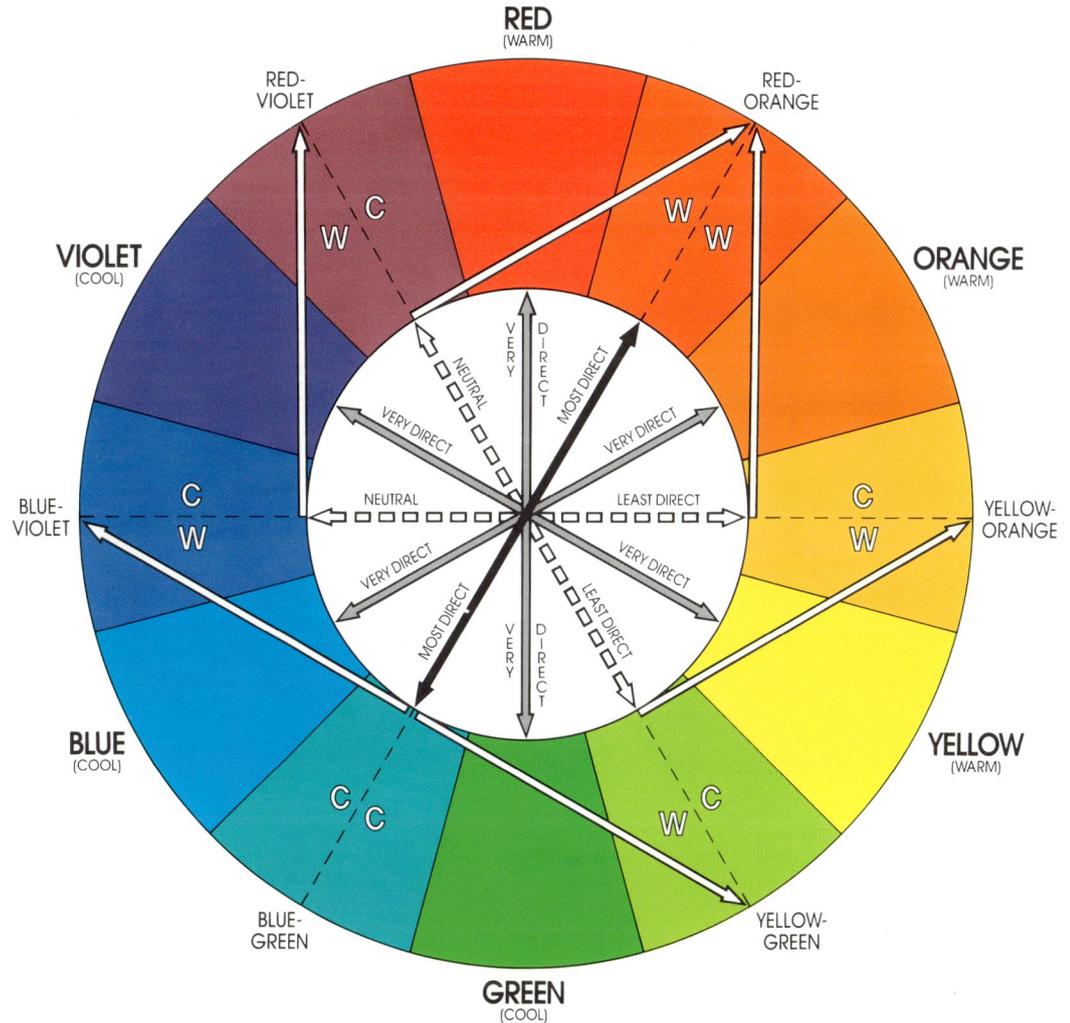

Opposition and Fluctuation in Temperature Polarity Within the Color Wheel

The black arrow crossing the wheel shows a direct temperature polarity (most extreme opposition) between red-orange and blue-green. The W and C markings indicate the warm and cool side of each hue (WW = Warmest, CC = Coolest, WC = Neutral).

Note that the spike in the rising temperature occurs at WW and the dip in lowest temperature occurs at CC. The white arrows within the bands of hue indicate the direction of rising temperature. The dotted lines crossing the wheel indicate the points of relatively neutral temperature opposition, and the gray arrows indicate points of strong, direct, temperature opposition.

Alan Peckolick.— "Typography, the letter-form, is very exciting to me, very beautiful and sensuous . . . intensifying. In typography the purest connection is the ampersand, which connects not only words and letters but thoughts, ideas and philosophies. I chose Goudy Old Style, one of the most beautiful, classic typefaces, and interlocked the ampersands, visually showing the connection of the connectors. I went through an agonizing process, exploring many different designs and different ampersands. I had to keep refining and making the design purer and purer so it would work with my idea of the purest connection."

Simpson
making paper . . .
perform!

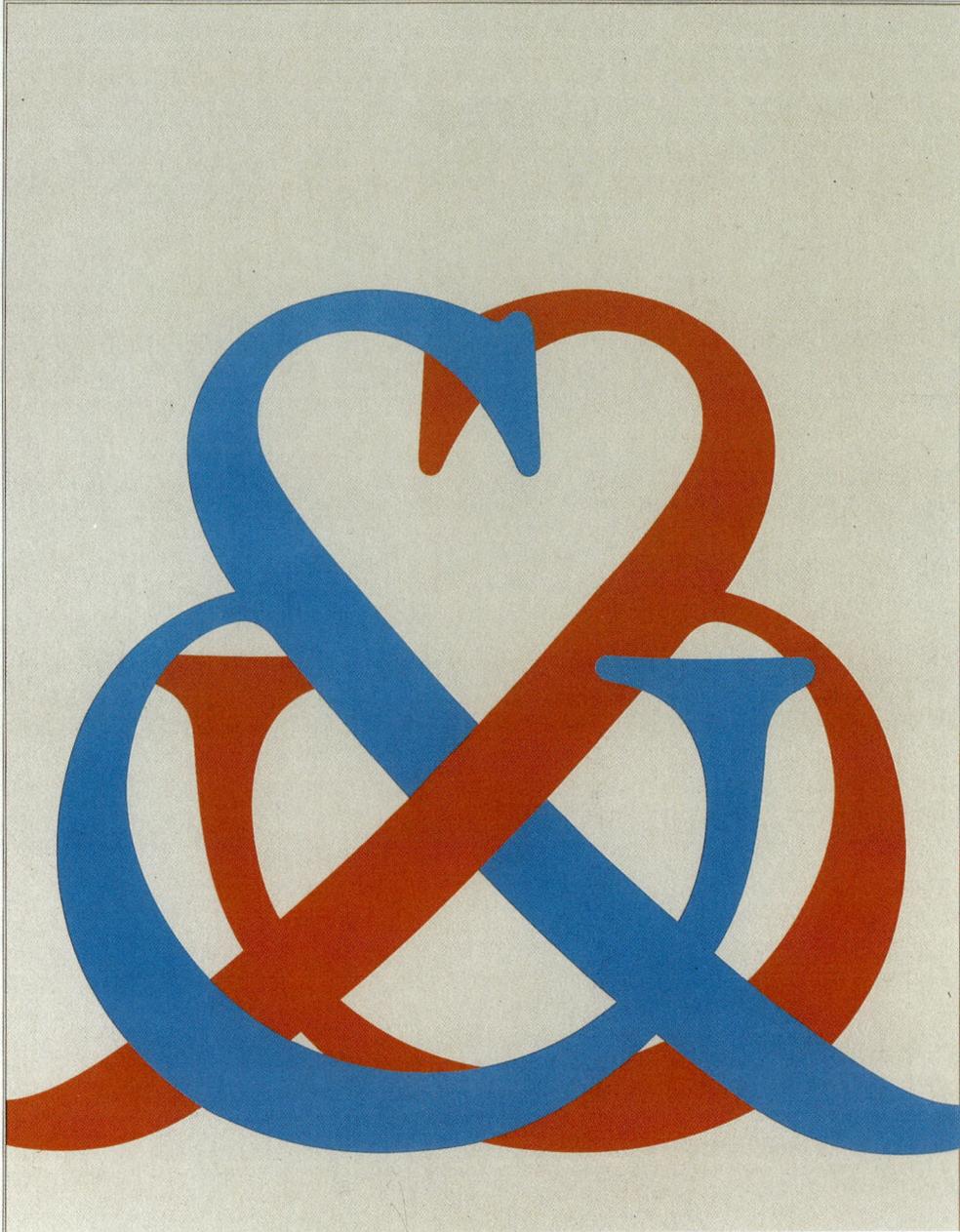

ALAN PECKOLICK
ON
Designing with Type and Color

Typography, like photography, has two basic concerns: black-and-white, and color. In photography, color subjects can be translated into black and white, while in typography, what originates as black and white can be translated into color. In either case, the process involves a re-evaluation of the original state for the modified application.

Typography is also similar to photography in that both involve the creation of illusionary images. Letters make up words which build into sentences, which in turn build into paragraphs that we perceive as masses of tonal value. That same mass can change appearance when printed on different colored stocks or in colored inks, and even then we all see colors slightly differently.

This illusionary quality is one of the fascinating, though at times frustrating, aspects of translating black type into other colors. You just do not know for certain what the actual result will be until the piece is printed. Sometimes this is as much of a surprise as the ending of a mystery novel.

Is there too much yellow? What if I add some black? Is the screen too coarse? Should we use a tint? Maybe drop out the background? These uncertainties can be somewhat intimidating, and because of this, designers might be tempted to stick to safe color combinations, or to omit color altogether. Unfortunately, by taking the safe route, they sacrifice the excitement and visual impact that color can generate within a typographical composition. As a result, even a good design may fall short of being the most successful solution to a graphic problem.

Color selection should be guided by three key factors: intuition, knowledge and experimentation.

Intuition is a personal sensitivity which influences all aspects of design. Design based solely upon intuition, however, is something of a hit-or-miss process, especially in the area of color, and some designers are naturally more successful with this approach than others. All designers benefit from coupling intuition with knowledge and experience.

Designers can achieve their best results only if they understand the relationships among typeface, point size, color and

ALL: THE WHOLE AMOUNT OR QUANTITY OF

Mobil
Masterpiece
Theatre
presents

FOR: USED AS A FUNCTION WORD TO INDICATE PURPOSE

All For Love

LOVE: 1. STRONG AFFECTION FOR ANOTHER ARISING OUT OF KINSHIP OR PERSONAL TIES 2. ATTRACTION BASED ON SEXUAL DESIRE 3. AFFECTION BASED ON ADMIRATION, BENEVOLENCE, OR COMMON INTERESTS

A SERIES OF FIVE PLAYS BEGINS ON SUNDAY, MAR. 31 STARRING JOAN PLOWRIGHT, ALEC McCOWEN 9 PM CHANNEL 13 PBS HOST: ALISTAIR COOKE

Mobil

production. A good design can fail if technical considerations are not included in the design process. Designers must understand that while printing, say, seven point Bodoni Book in a solid color ink might not present problems, creating that same hue through four color process might. They must also understand the transformation from color swatch to letterform. Designers generally select colors from sample swatches which are solid patches of colors and unrelated to the actual weight of the type. Since text copy is a textured mass rather than a solid, reproduction will appear lighter than the designer had intended. In addition, a color that reads well on white stock might be unreadable on blue.

Designers must also be aware that a successful collaboration between typography and color requires a sensitivity to refinements. Just as a photographer can alter the atmosphere of a photograph through subtle shifts in lighting, so too can designers control the effect of a design through subtle changes in point size and tonal value. Copy that projects well in black, for instance, if printed in another color might require a change in point size in order to maintain the same visual intensity.

Experience, being the best teacher, reduces production judgement errors. It is a wise designer who learns from past mistakes. Any piece, however, can confront designers with situations they have not previously encountered. While produc-

*"Color should bring something special to a design.
Introducing color for color's sake is a crutch, which should not be used
to support a failing design."*

tion limitations are a practical consideration, a creative collaboration between designer and printer can resolve most problems. This confidence gives the designer the freedom to experiment.

Color should bring something special to a design. Introducing color for color's sake is a crutch which should not be used to support a failing design. Certain typographical applications are more conducive than others to the use of color. When color is appropriate, or even essential, designers must be sensitive to color impact and tailor its selection to fit the visual, and the message. Color is a valuable design tool and many factors influence color selection. The mood of the piece, the designer's personal preference, cultural associations, and production specifications all play a role in determining color selection. For example, a piece about war or revolution might immediately bring to mind the color red for the headline. This is a spontaneous association related to our traditional influences. Another color that is not so obvious, however, might work even better, so designers should experiment and go beyond first impressions.

Contemporary designers can gather great inspiration from the work produced during past periods. One of the most fertile eras of experimentation in typography and color was that of the progressive movements in Europe during the early years of the 20th Century. These movements included the Constructivists, Avant Garde, Bauhaus and DeStijl. Those designers consciously moved away from the traditional to a more radical time of experimentation.

If an experiment is successful, it will eventually be copied by others, and a new movement-or shorter lived trend-emerges. The New Wave trend of the early 1980's developed a typographical style through spacing and typeface selection which was influenced by these earlier progressive artists. They, however, substituted for the distinctive colors of those movements with pastel tones, and this coloring has become an important hallmark of the New Wave style.

The creative spirit will always seek innovative means of expression, whether through original statement or through a modified renaissance of a previous concept. The possibilities of typography and color are as limitless as the designer's imagination.

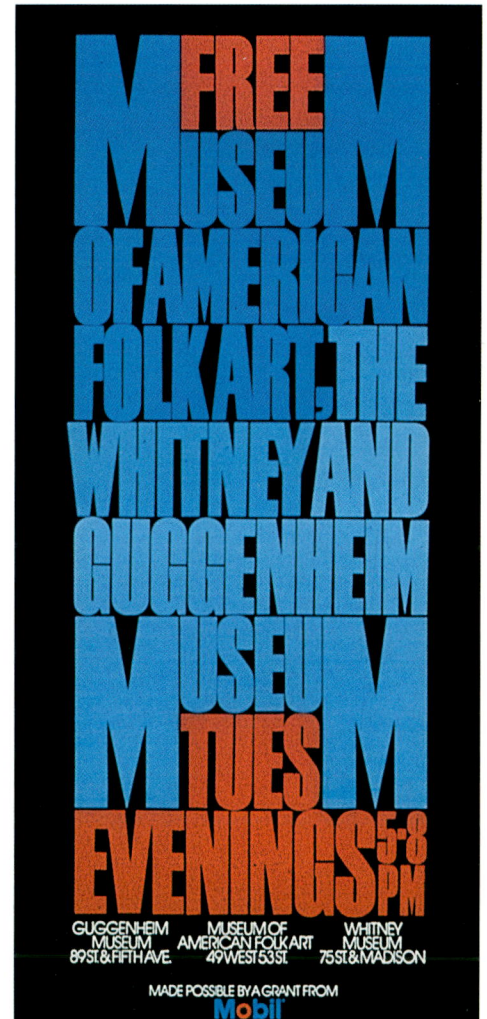

FREE MUSEUM OF AMERICAN FOLK ART, THE WHITNEY AND GUGGENHEIM MUSEUM TUES EVENINGS 5-8 PM

GUGGENHEIM MUSEUM 89 ST & FIFTH AVE. MUSEUM OF AMERICAN FOLK ART 49 WEST 53 ST. WHITNEY MUSEUM 75 ST & MADISON

MADE POSSIBLE BY A GRANT FROM
Mobil

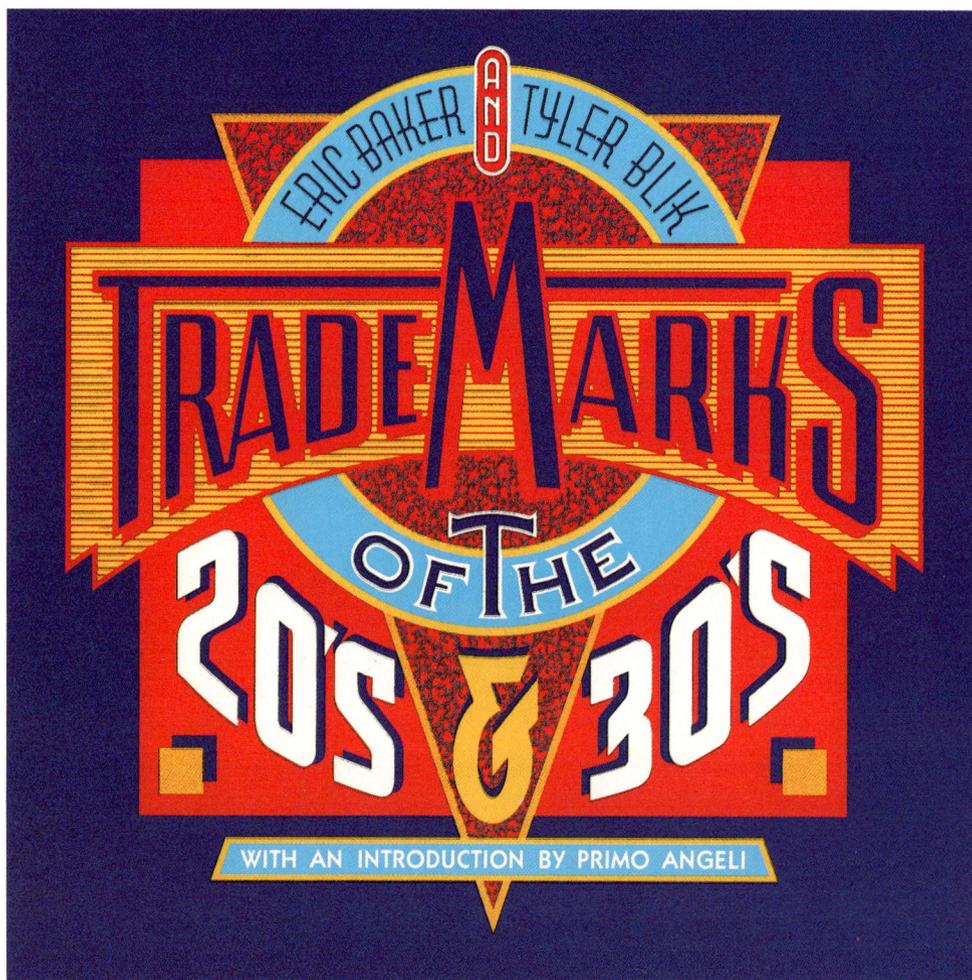

ERIC BAKER AND TYLER BLIK

TRADEMARKS OF THE 20'S & 30'S

WITH AN INTRODUCTION BY PRIMO ANGELI

DESIGNER/ILLUSTRATOR: Michael Doret

Done in flat and mostly primary colors, this book cover is a finely crafted trademark itself, in the tradition of thousands of cigar boxes, orange crates and enamelled signs of the period. While this approach sometimes results in more torture than design where the letterforms are concerned, here the shaping was done with restraint and respect for readability. Even the blue title outlined in red works well because of the yellow field.

CLIENT: HBO Video, Inc.
AGENCY: Designed to Print & Associates, Ltd.
ART DIRECTORS: Tree Trapanese, Peggy Leonard, and David Un
PRODUCTION DIRECTOR: David Un
TYPOGRAPHER: Tree Trapanese

A series of four related video packages, done in very subtle shades reminiscent of the murder mysteries' heyday. This unified collection of distinctive designs, with its geometric letterforms and sophisticated color combinations, welcomes the shopper to share in these classic mysteries.

GREAT

COMBINATIONS

In the immortal words of somebody, "The cheapest experience you can get is someone else's". In this section, you'll be able to take a close look at the best work of several very talented designers and typographers, and to investigate in detail exactly why these pro's did what they did.

The examples we've chosen to examine here are specimens of color/type use at its best. They are not the only ones we had an opportunity to display; indeed, many beautiful works had to be passed over for the sake of space. But they do represent a large number of professionals solving a wide assortment of problems.

As you'll see, great designs…and designers…are to be found in every print specialty, not just magazine ads. We're proud also to show off examples of the best recent work in posters, book and magazine covers, and more. This is more, though, than just a gallery upon which to feast the eye. By being able to, in effect, look over the shoulders of these talented people, we can study why they approached each challenge the way they did, and how they succeeded.

GREAT COMBINATIONS is a valuable segment of this work, and as an attentive professional we feel confident that you'll use it at every opportunity as a source of information, enjoyment and inspiration. Good Hunting!

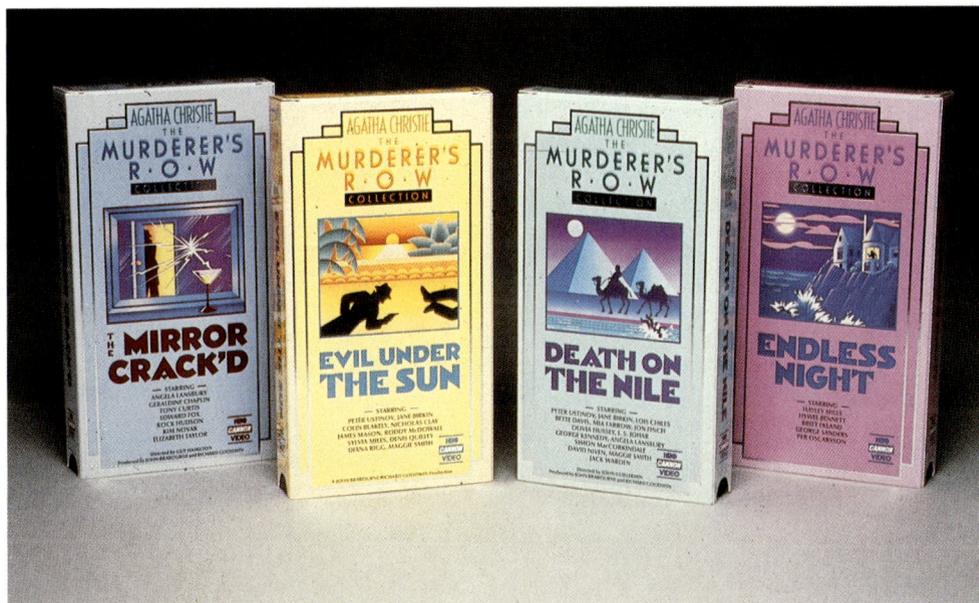

ART DIRECTOR: Judith Loeser
DESIGNER/TYPOGRAPHOR: Daniel Pelavin
PUBLISHER: Vintage Books

Warm grays on an earthy ivory field make for a pleasing and easily readable title setting; one which harmonizes very nicely with the soft blue cover. A sophisticated combination, helped by the use of the ivory in the tile-like design and the reverse below.

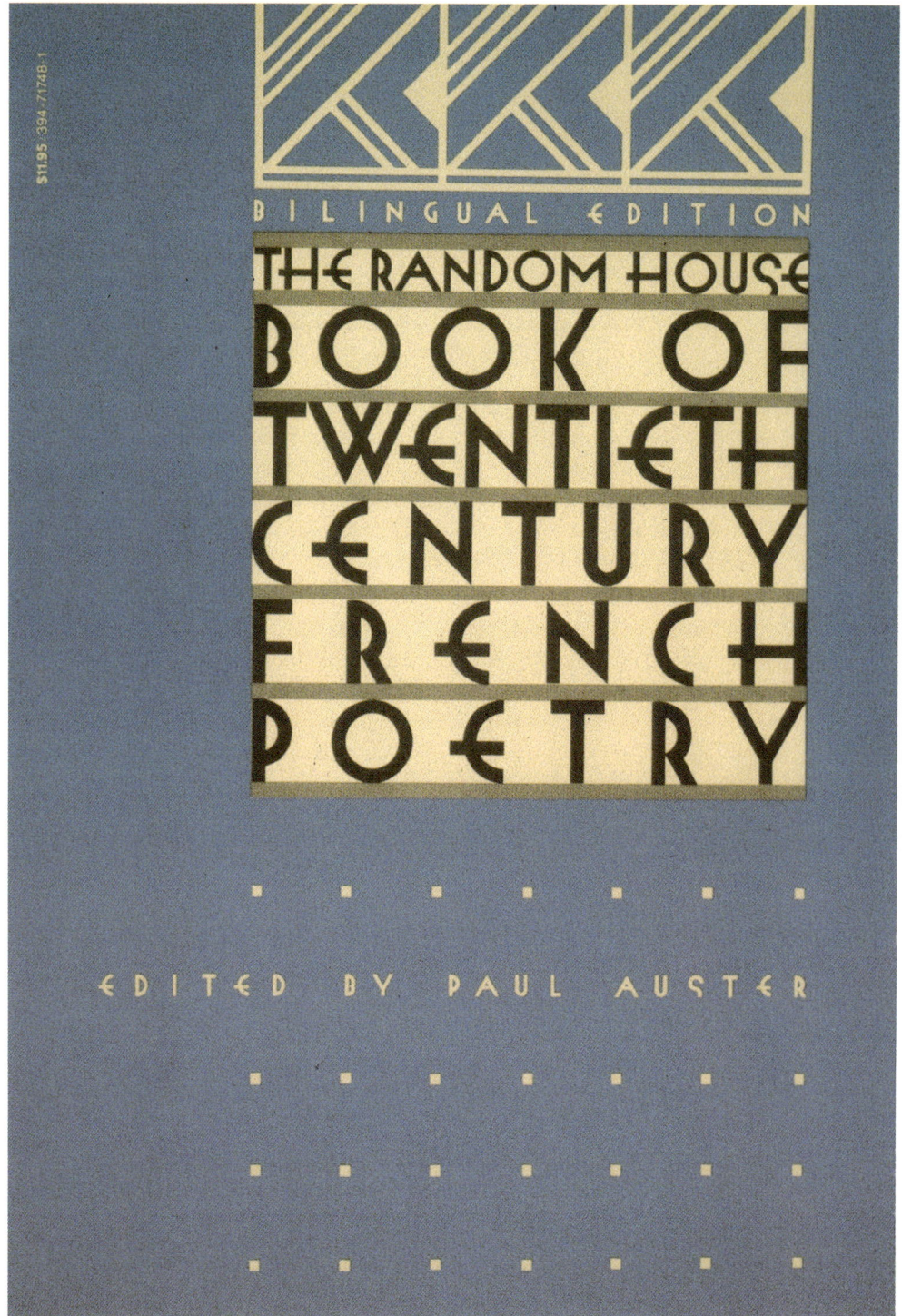

BILINGUAL EDITION

THE RANDOM HOUSE
BOOK OF
TWENTIETH
CENTURY
FRENCH
POETRY

EDITED BY PAUL AUSTER

$11.95 · 394-71748-1

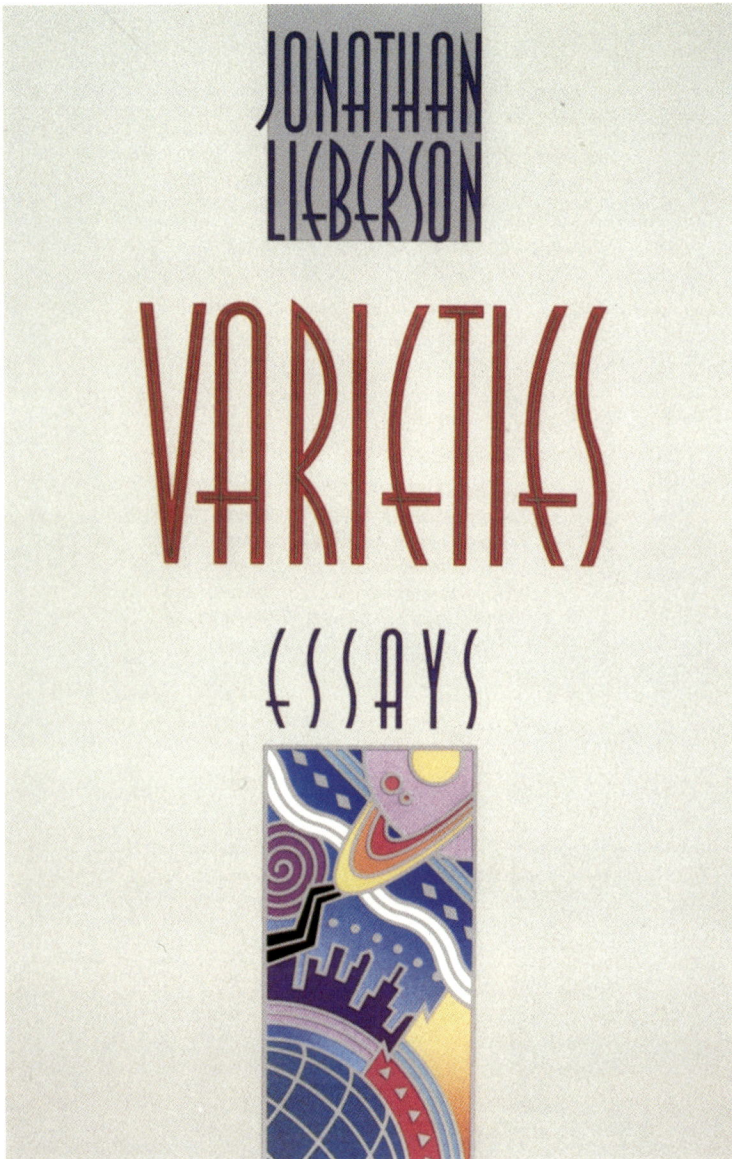

JONATHAN LIEBERSON

VARIETIES

ESSAYS

ART DIRECTOR: Cindy LaBreacht
DESIGNER/TYPOGRAPHER/ILLUSTRATOR: Daniel Pelavin
PUBLISHER: Weidenfeld & Nicolson

The same typeface doing three different things at once. The title, "Varieties" in red on white dominates the cover, its strongly vertical letterforms anchoring a very vertical design that seems to make the book taller. The lavender type above and below work well with the red, each contributing something different to the design. Nothing tricky here ...just a decorative and difficult type style used to its best advantage.

ART DIRECTOR: Judith Loeser
DESIGNER/TYPOGRAPHER/ILLUSTRATOR: Daniel Pelavin
PUBLISHER: Vintage Books

The lavenders with the honey gold make a legible, visible yet civilized combination. The letterforms seem more Art Nouveau than Art Deco, the style inspiring the background, but these two approaches flirt well and the result is a welcoming design that doesn't rely on big, loud type.

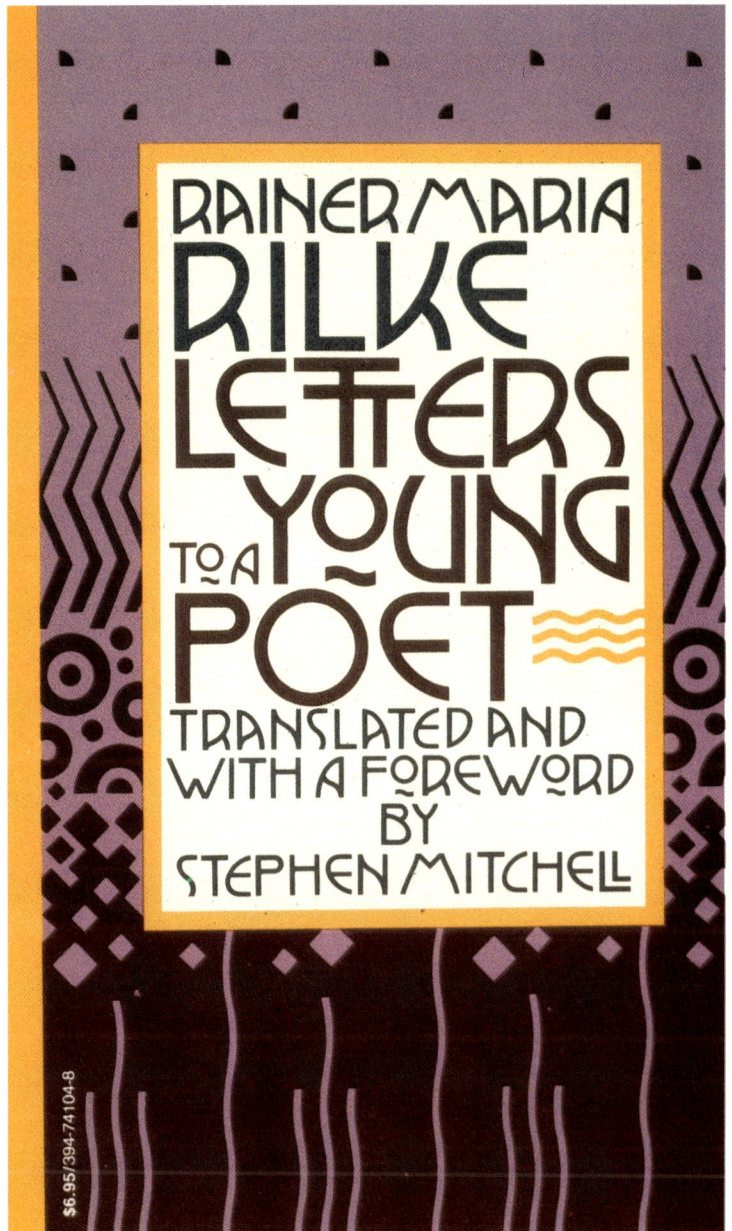

RAINER MARIA
RILKE
LETTERS
YOUNG
TO A
POET
TRANSLATED AND
WITH A FOREWORD
BY
STEPHEN MITCHELL

$6.95/394-74104-8

DESIGNER: Andy Carpenter
PUBLISHER: St Martin's Press

This book cover demonstrates many proven techniques for assuring visibility, legibility and intrigue on the store shelf. The warm, red-orange title in tall, sharp-edged type on a white ground reads quickly. The color gradation in the type is echoed below in a harmonious blue-green that anchors the bottom of the design and brings out the drop-shadowed author's name. A barely noticeable pale blue-green drop shadow in the title helps to tie this design together.

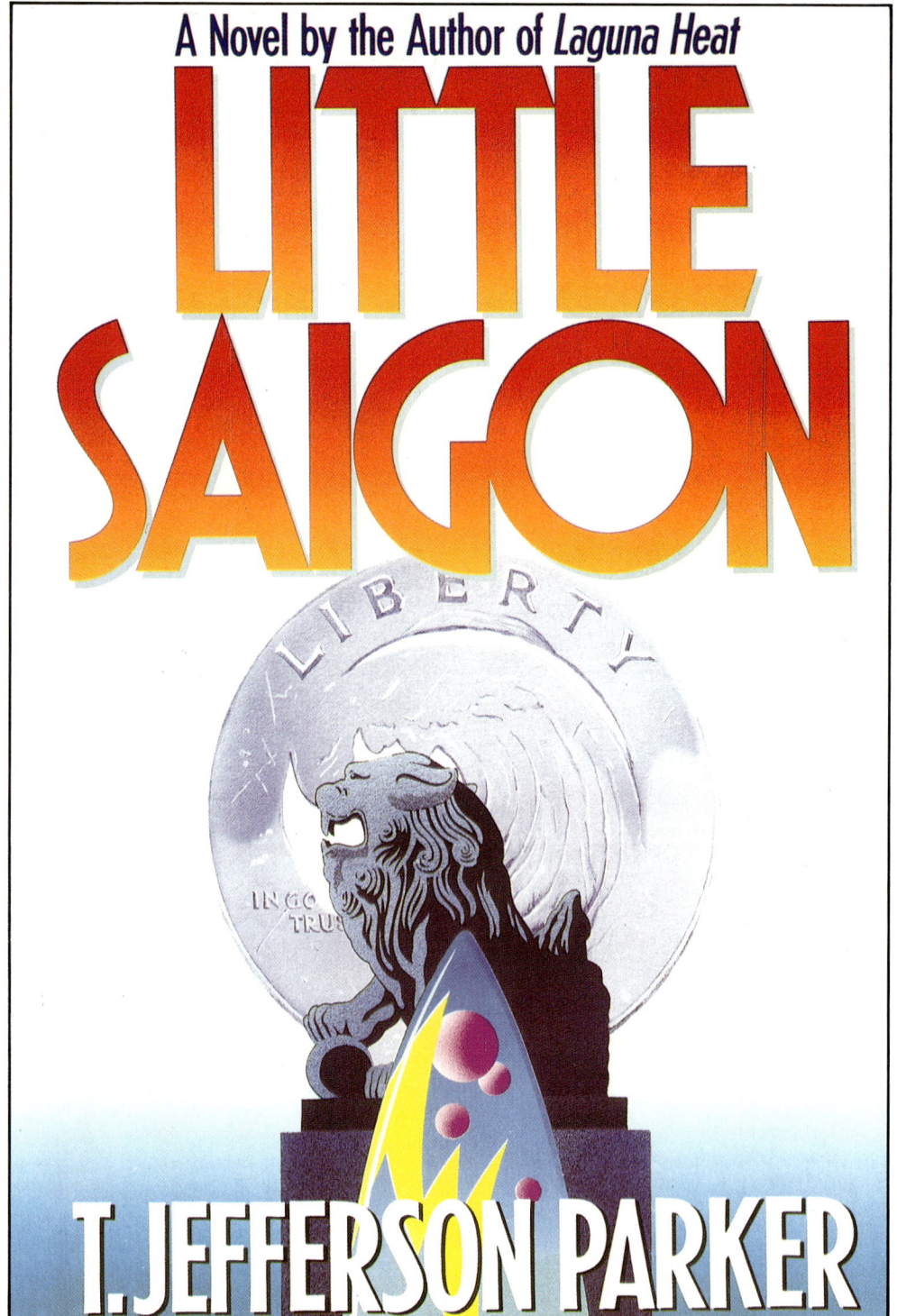

A Novel by the Author of *Laguna Heat*

LITTLE SAIGON

LIBERTY

IN GO
TRUS

T.JEFFERSON PARKER

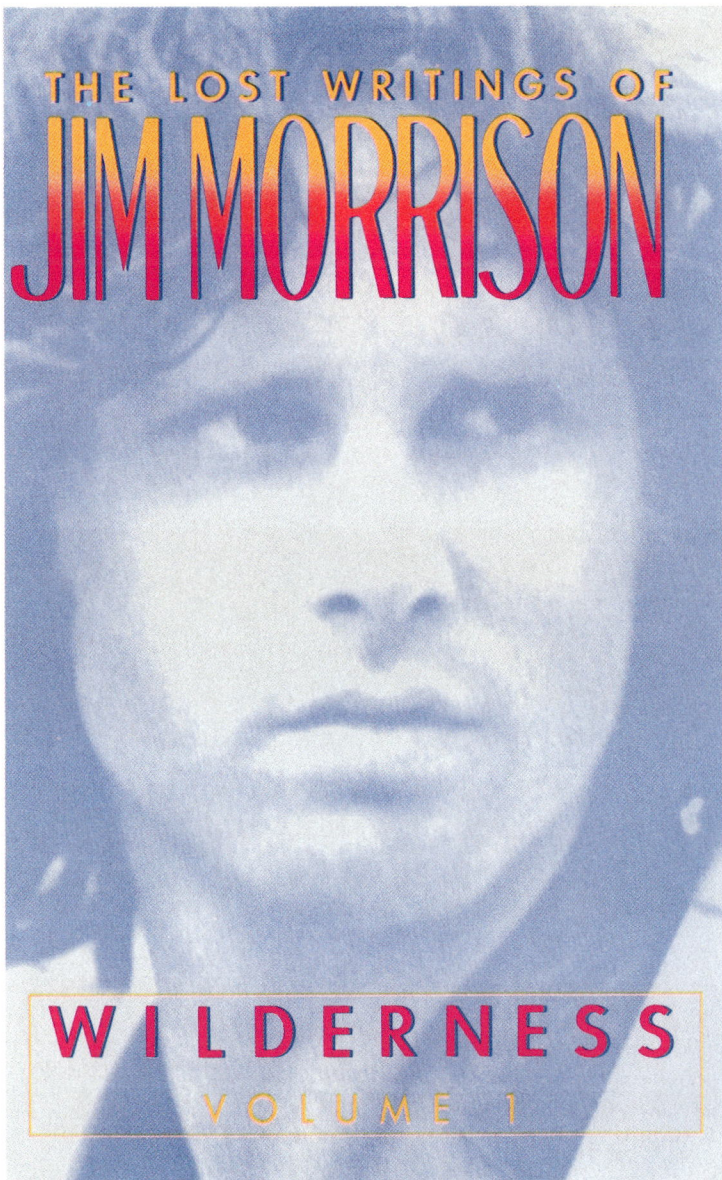

THE LOST WRITINGS OF **JIM MORRISON**

WILDERNESS

VOLUME 1

CLIENT: Villard Books/Random House
ART DIRECTOR: Wendy Bass
PRODUCTION DIRECTOR: Lita Evanthes
PHOTOGRAPHY: Frank Lisciandro
TYPOGRAPHER: Photolettering
ENGRAVER/PRINTER: Coral Graphics

This book cover combines harmonies and contrasts very well in seeking to convey the mysterious, "lost" quality of the work while at the same time competing successfully on the bookstore shelf. The portrait is a very atmospheric, distant shot in direct counterpoint with the almost incandescent colors of the type.

DESIGNER/ILLUSTRATOR: Michael Doret

They're all there: the fake wood grain, the impossible rocket, the unexplained triangle and textured boomerang ...and the intentionally naive typography that so easily recalls all those old record albums. This wonderful junkyard of perfectly balanced type and color does exactly what it has to do. It reads fast, establishes its own character, and makes you want to look inside.

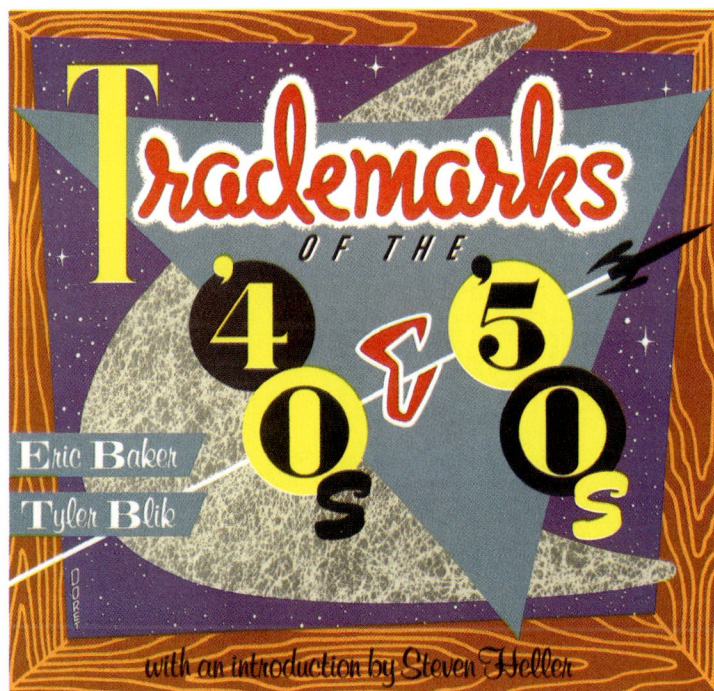

Trademarks OF THE '40s & '50s

Eric Baker
Tyler Blik

with an introduction by Steven Heller

DESIGNER/ILLUSTRATOR: Michael Doret

A telegraphic cover that, despite its intentional hodge-podge retail-ish approach, reads quickly, and uses broad, comic book colors to relay immediately the sense of bargain basement cheapness that's this lead story's theme.

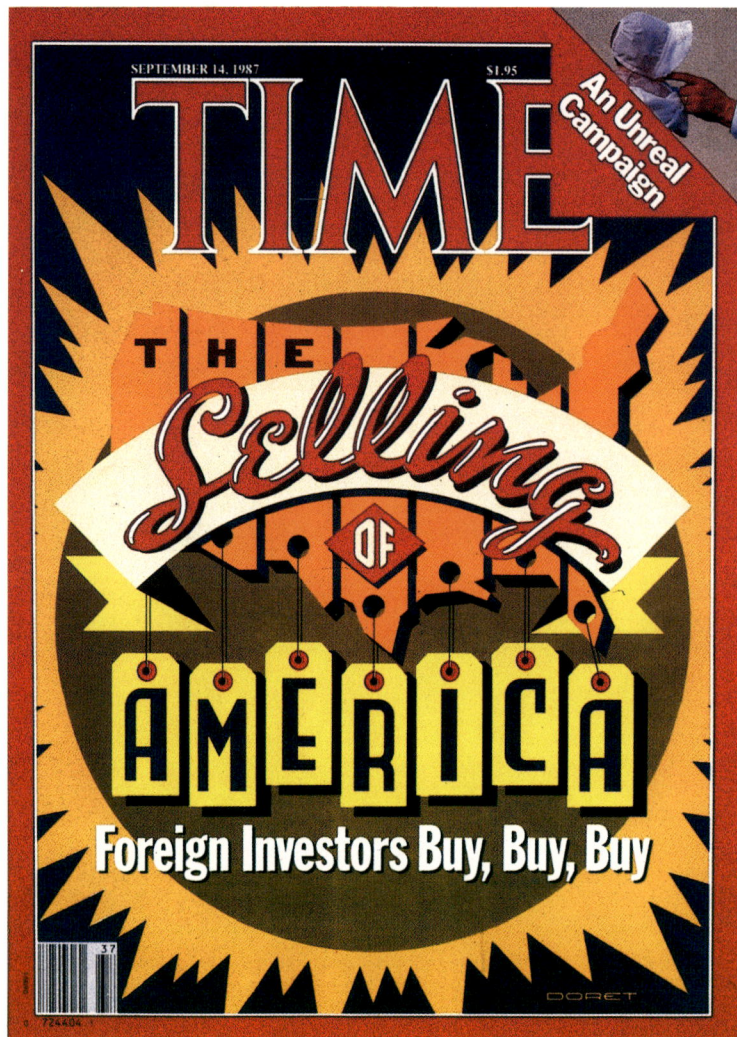

DESIGNER/ILLUSTRATOR: Michael Doret

A prime example of the magazine cover as small poster. The royal blue, metal-edged, sharp-pointed letters on the toasty gold background tell the browser exactly what Time is interested in this week. The choice of colors here helps to overcome the similarity between this lettering and the magazine's well established masthead.

EXCLUSIVE INTERVIEW
PATRICK SWAYZE

A CELEBRATION OF STYLE

FEBRUARY 1989

$1.95

MODEL

CHYNNA PHILLIPS

GETAWAY FASHION

JAMES DEAN REVISITED

RACY SWIMSUITS

PARADISE!

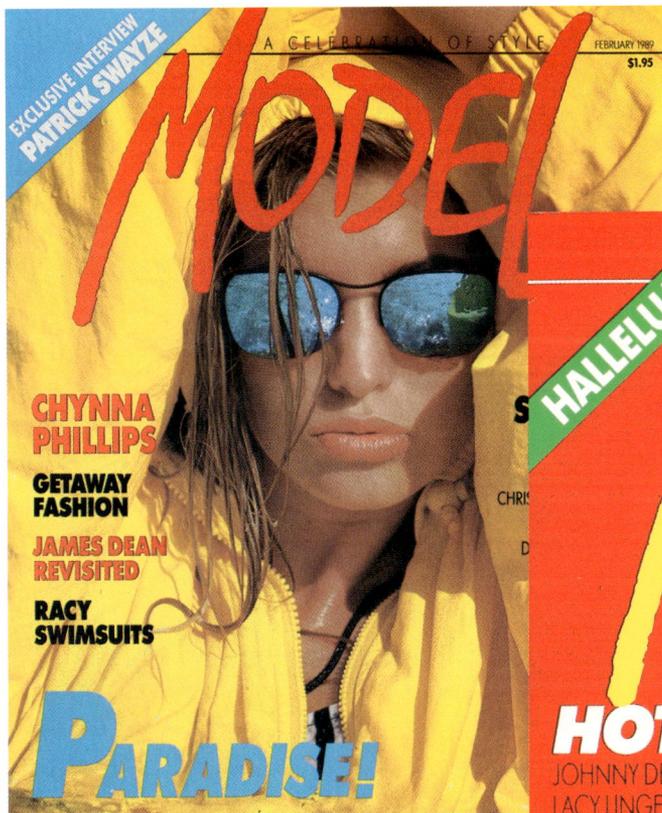

This late-winter cover says "Sunshine" and says it quickly. The red title on the brilliant yellow jacket needs only the blue of the reflected swimming pool to complete the vacation theme. The blue corner snipe and the blue type at the bottom of the page provide the overall balance this page needs.

CLIENT: Model Magazine
ISSUE: December, 1988
ART DIRECTOR: Martin Jacobs
PHOTOGRAPHER: Mike Reinhardt
TYPOGRAPHER: Gerard
ENGRAVER/PRINTER: Baird-Ward

This bright yellow hand-lettered title on the hot red-orange background is a clear winner in its uncompromising visibility, and yet, because these two colors vary so much in value and hue, the eye is not jarred by the combination. In comparison, the pure white subheadings appear actually cool.

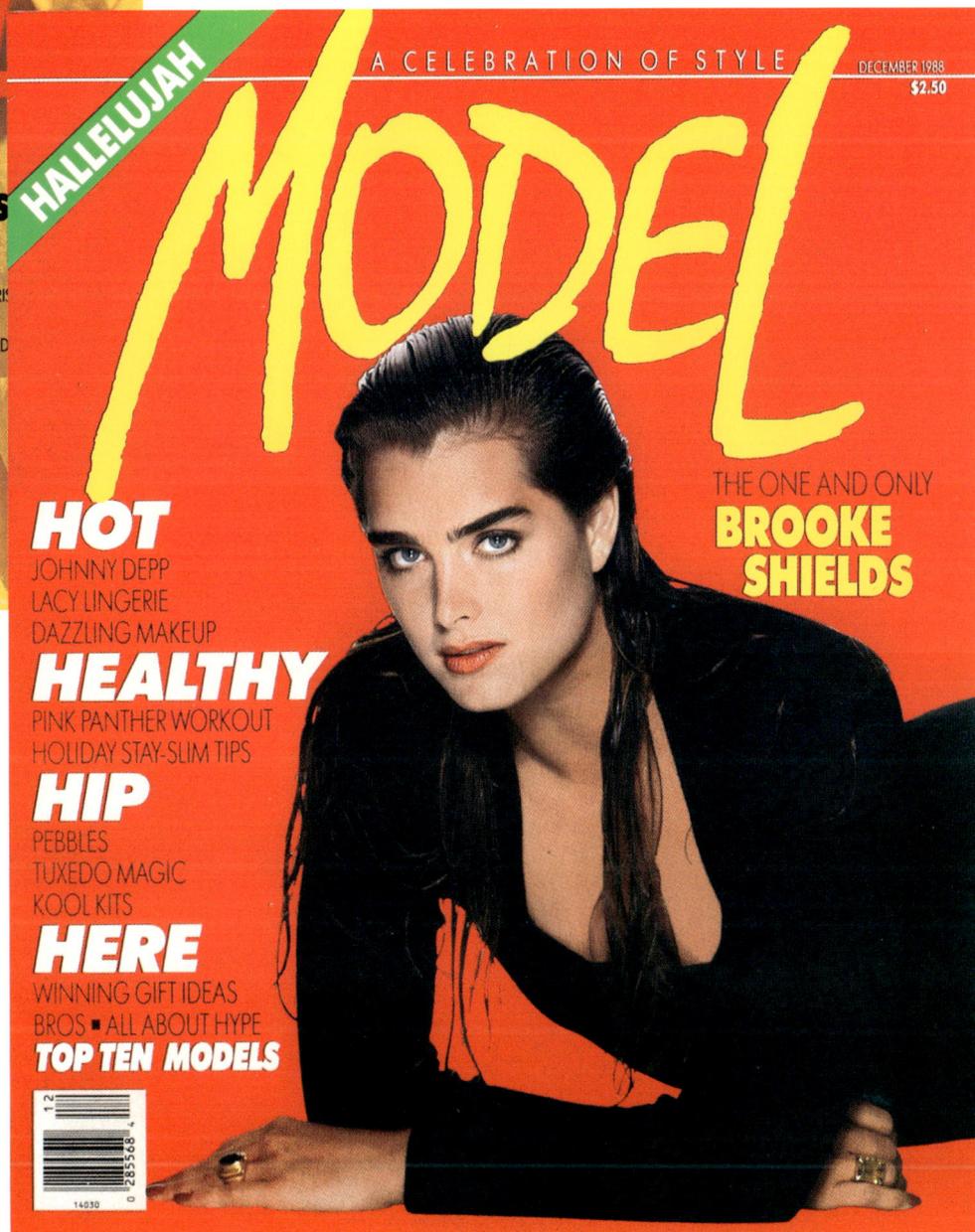

HALLELUJAH

A CELEBRATION OF STYLE

DECEMBER 1988

$2.50

MODEL

THE ONE AND ONLY
BROOKE SHIELDS

HOT
JOHNNY DEPP
LACY LINGERIE
DAZZLING MAKEUP

HEALTHY
PINK PANTHER WORKOUT
HOLIDAY STAY-SLIM TIPS

HIP
PEBBLES
TUXEDO MAGIC
KOOL KITS

HERE
WINNING GIFT IDEAS
BROS ■ ALL ABOUT HYPE
TOP TEN MODELS

ART DIRECTOR: Dennis Freedman
ASSOCIATE ART DIRECTOR: David Jaenisch
PRINTER: Holiday-Tyler

The muted colors combined with the huge numeral "100" make the perfect background for this issue's lead article, displayed in a sandy yellow with drop shadow. Everything about this cover seems to say "civilized man"... a blend of gray flannel and strength applied with judgement and taste.

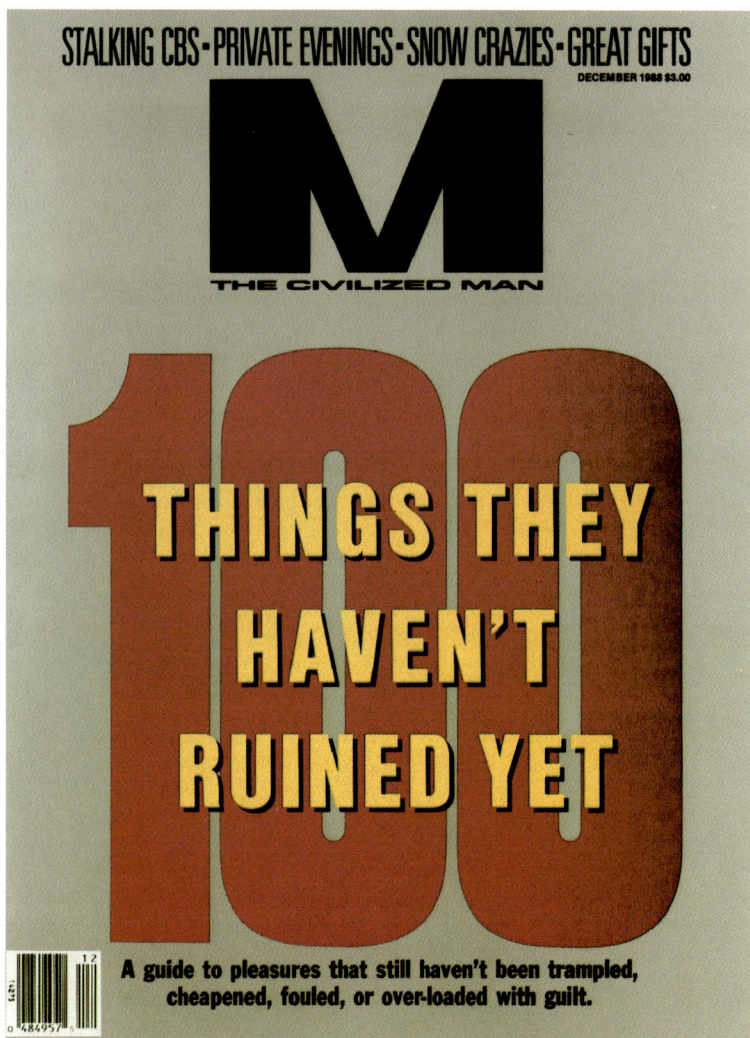

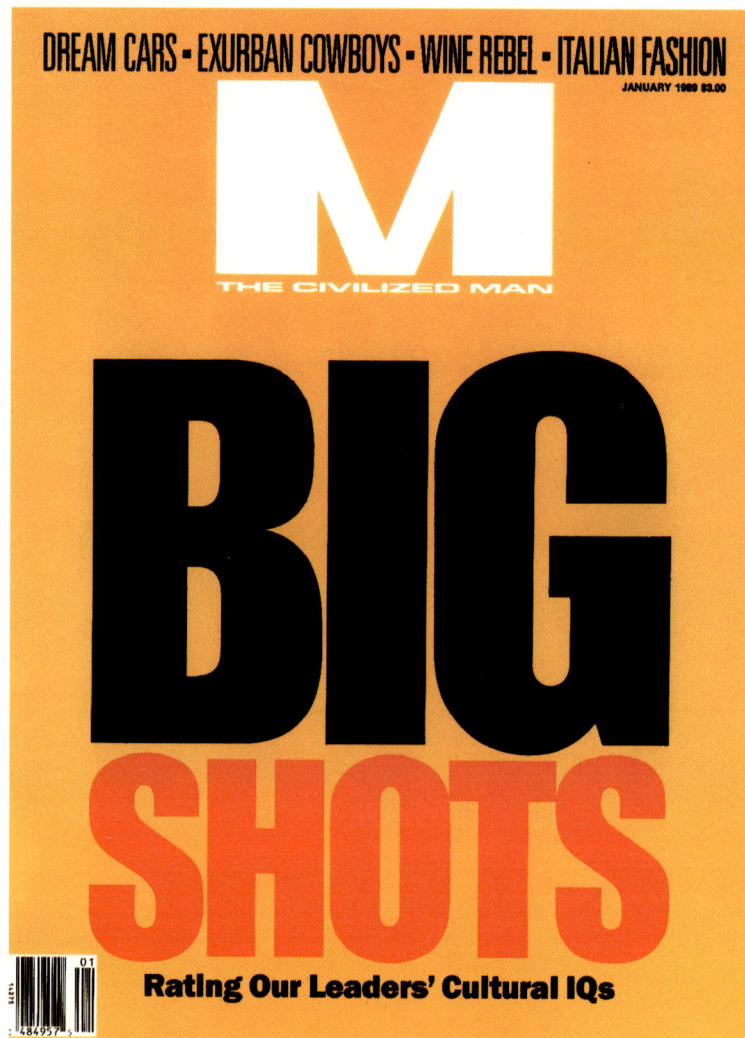

STALKING CBS · PRIVATE EVENINGS · SNOW CRAZIES · GREAT GIFTS

DECEMBER 1988 $3.00

M

THE CIVILIZED MAN

100

THINGS THEY HAVEN'T RUINED YET

A guide to pleasures that still haven't been trampled, cheapened, fouled, or over-loaded with guilt.

DREAM CARS · EXURBAN COWBOYS · WINE REBEL · ITALIAN FASHION

JANUARY 1989 $3.00

M

THE CIVILIZED MAN

BIG SHOTS

Rating Our Leaders' Cultural IQs

ART DIRECTOR: Dennis Freedman
ASSOCIATE ART DIRECTOR: David Jaenisch
PRINTER: Holiday-Tyler

Here's a civilized cover that's anything but understated elegance. The black and red title, "BIG SHOTS" blows its own horn loud and clear. This is bold, attention-getting covermaking that doesn't rely on anything bizarre to attract even the casual, even the distant, browser.

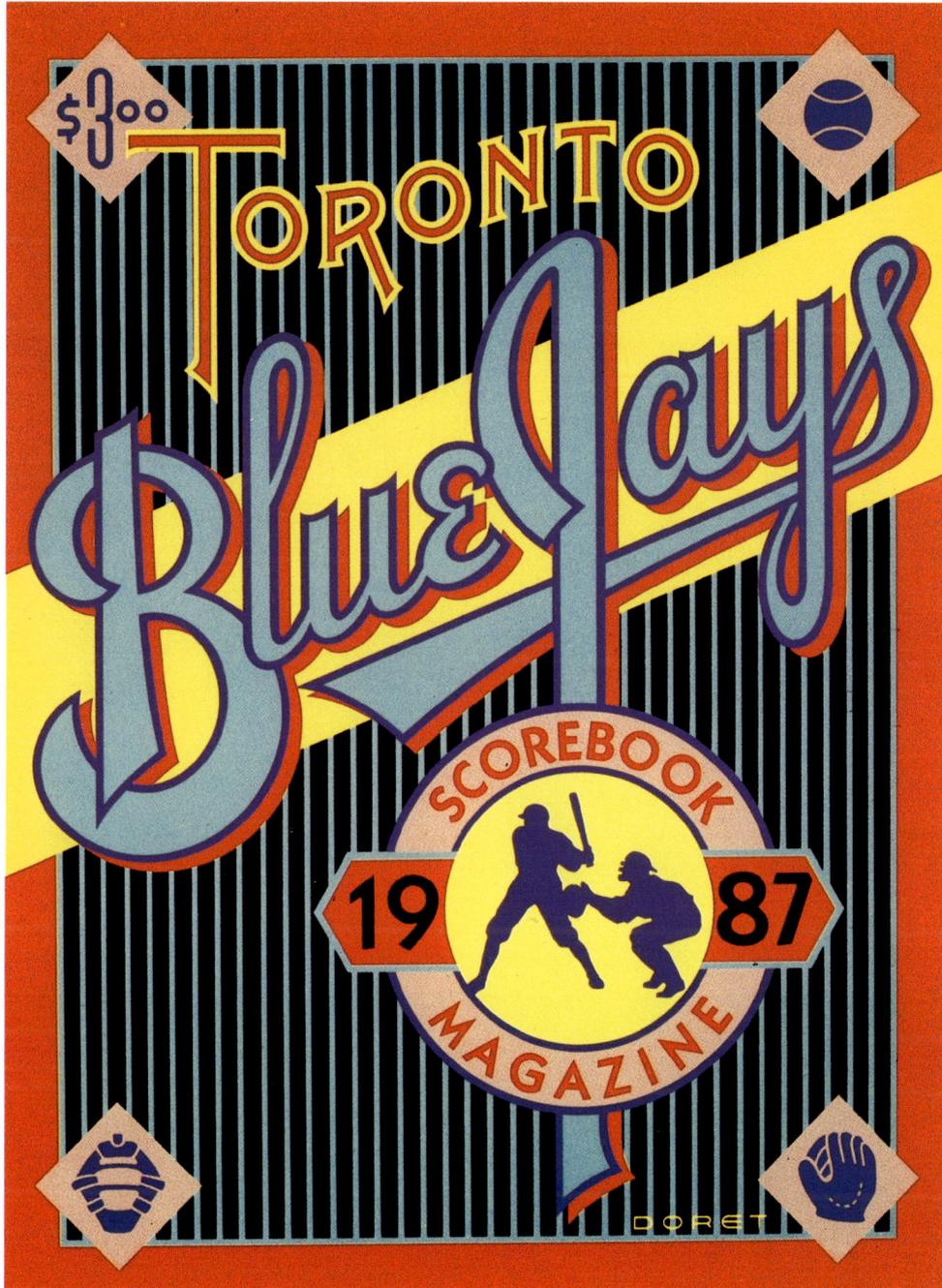

CLIENT: Toronto Blue Jays
ART DIRECTOR: Michael Doret

Nothing understated here. This old-fashioned good time baseball scorebook makes use of all the motifs and bright, flat colors that characterized printing in the early years of the century. In a turnabout, the blue title on the yellow background is drop-shadowed in red...a seeming violation of basic legibility rules. In fact, the red and blue here do not vibrate, and this arrangement softens what might otherwise have been just a modern banner rendered in nostalgic style.

CLIENT: Columbia Pictures International
AGENCY: Designed to Print & Associates, Ltd.
ART DIRECTORS: Peggy Leonard, Tree Trapanese, David Un
PRODUCTION DIRECTOR: David Un
PRINTER: Atwater Press

A fancy, old-fashioned shoot-em-up wild west movie poster. A lot of fun, just like the movie, and the title, glowing in the black background is definitely the hero. Notice how the letters fade to black toward the top while the outlines fade to white. This brings the title off the bright illustration while contrasting it with the white type below. Very visible, very legible, very successful.

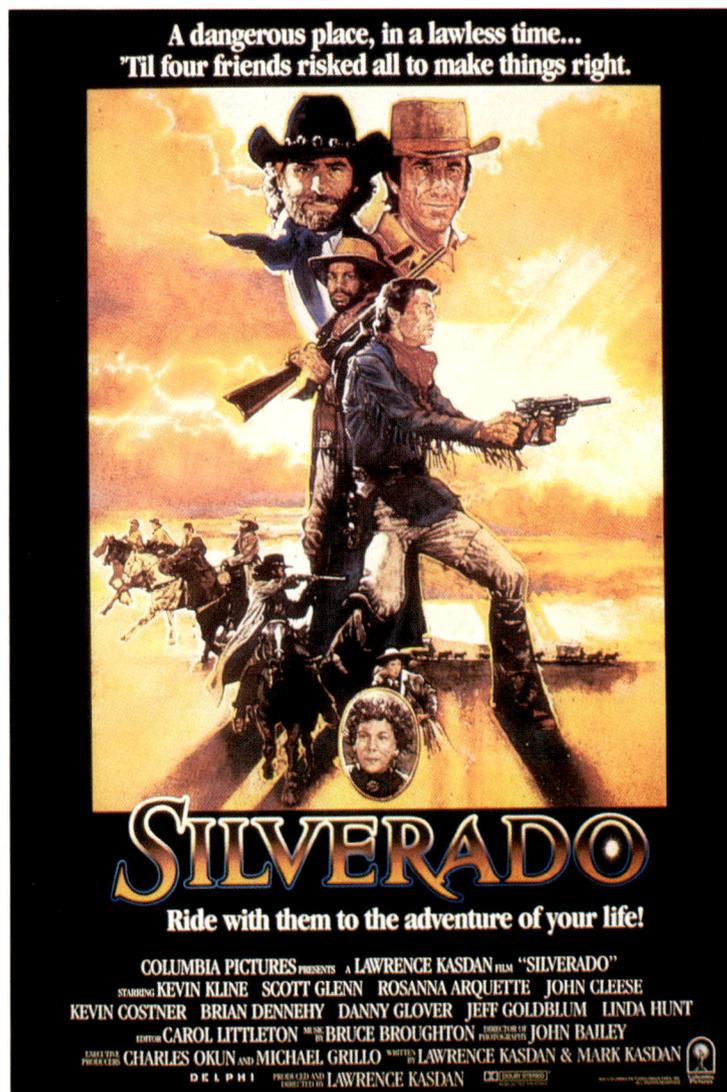

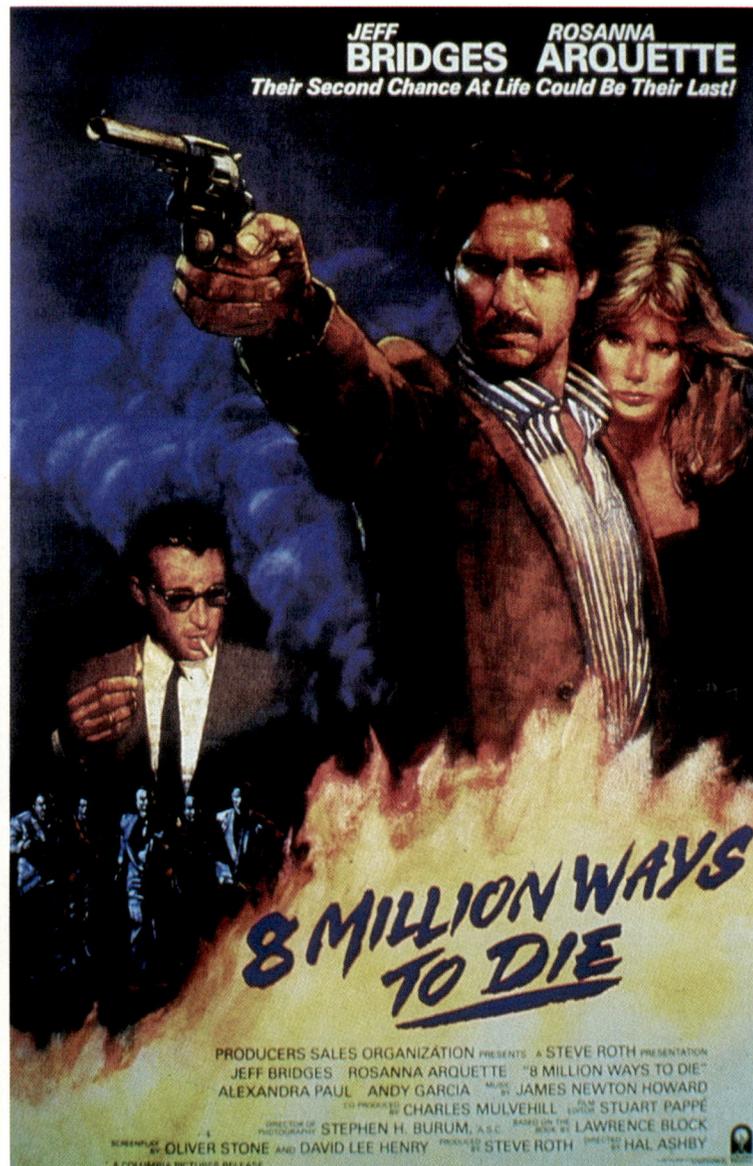

CLIENT: Columbia Pictures International, Inc.
AGENCY: Designed to Print & Associates, Ltd.
ART DIRECTORS: David Un, Tree Trapanese, Peggy Leonard
PRODUCTION DIRECTORS: David Un, Peggy Leonard
PRINTER: Kenner Printing

A violent theme brought across with violent lettering. The blue on yellow makes this title hard to miss, while picking up the smoky background. Here, the title needn't work with the reverse type at all since it is so far removed, but it does make the transition to the smaller blue type beneath it an easier one.

ART DIRECTOR: Judy Kirpich
DESIGNER/TYPOGRAPHER/ILLUSTRATOR: Daniel Pelavin
DESIGN FIRM: Grafik Communications, Inc.
PUBLISHER: Smithsonian Institution Traveling Exhibition Service

The restrained pastel combinations in a generally high key, along with the gentle fading of colors toward the bottom gives this design a definite feel of having been done on glass. A traffic-stopper by no means, this poster relies successfully for readership on being a work of Art Nouveau in its own right.

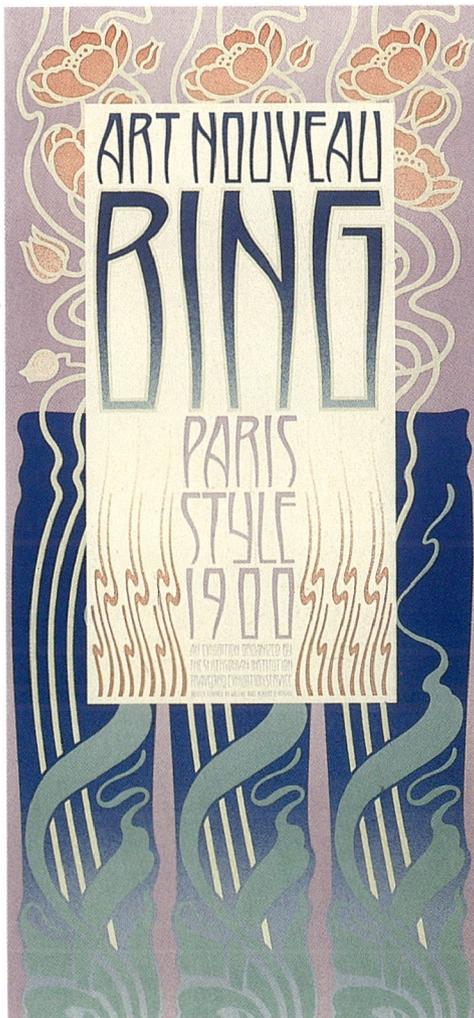

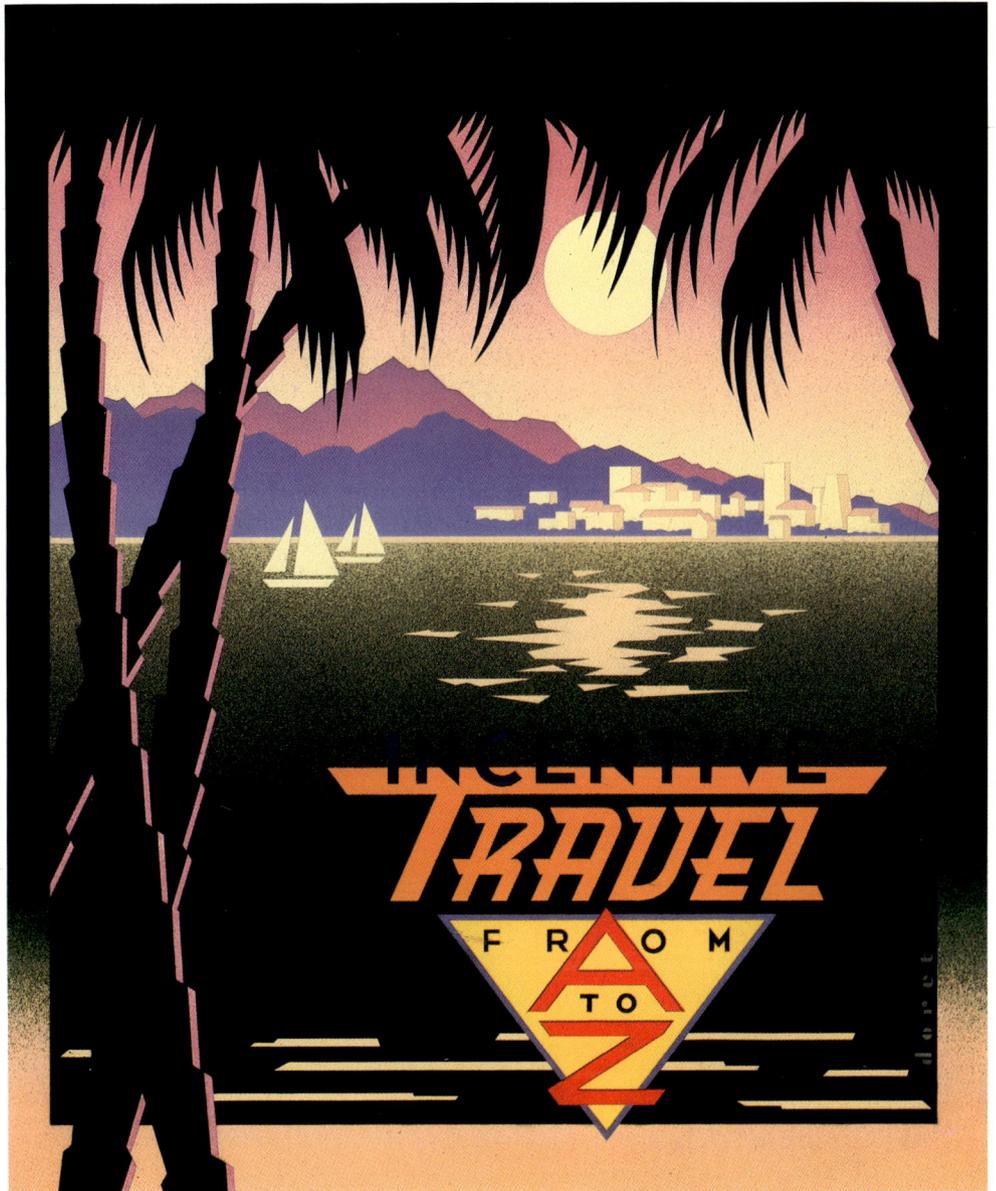

DESIGNER/ILLUSTRATOR: Michael Doret

This poster-within-a-poster cleverly lets you look through into another, faraway place, and the hand lettered orange word "Travel" on dark green tells you exactly what to do about it.

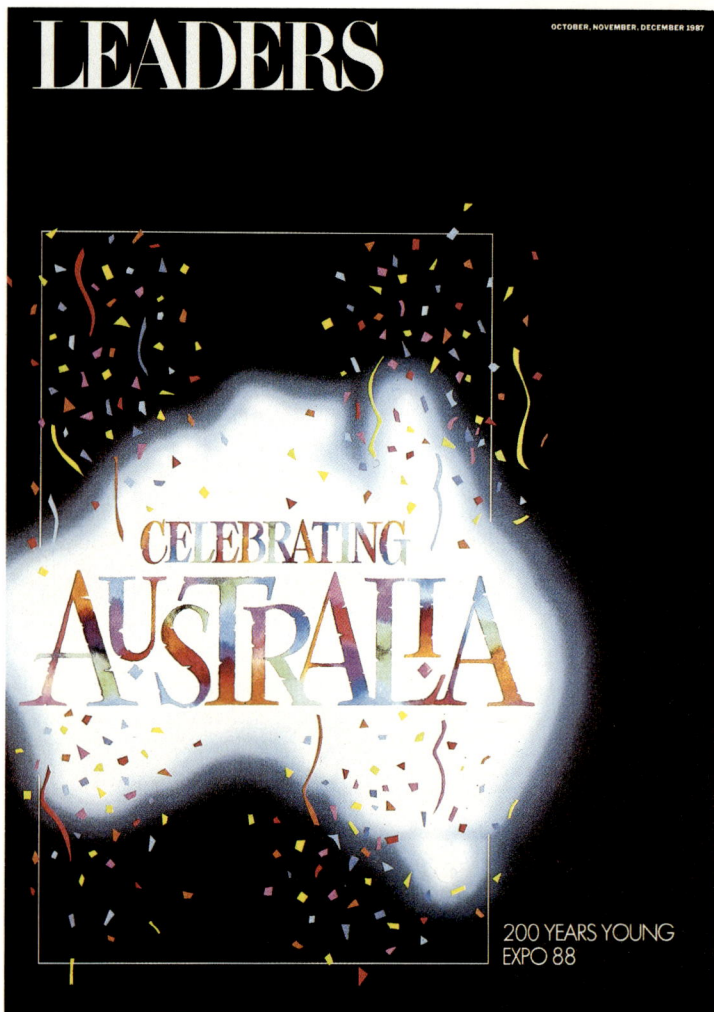

LEADERS

OCTOBER, NOVEMBER, DECEMBER 1987

CELEBRATING
AUSTRALIA

200 YEARS YOUNG
EXPO 88

CLIENT: Leaders Magazine
AGENCY: Besson & Tully
ART DIRECTORS: Joe Tully & Don Grimes
TYPOGRAPHER: Don Grimes

Festive hand lettering in pastel watercolors is particularly communicative in that, aside from the confetti, it's the only colorful element on the page. The broken-edged Roman face acts to preserve discipline amidst all this gaiety, the very casual use of letter size and placement bridging the gap between dignity and fun.

CLIENT: Bank of America
AGENCY: Cohn & Wells
ART DIRECTOR: Tom Joyce
PRODUCTION DIRECTOR: Cathy Bloodworth
TYPOGRAPHER: Rapid Typography
PRINTER: Graphic Arts Center

This brochure cover, designed around a 1920's theme, stresses easier, happier times. In fact, the title almost seems to read as "Easy Street." The red headline on the blue background loses none of its impact or legibility because of the extreme drop shadow, and as well, by the type reaching over onto the white. This red-on-blue headline leaps off the page without the annoying "vibration" we might expect.

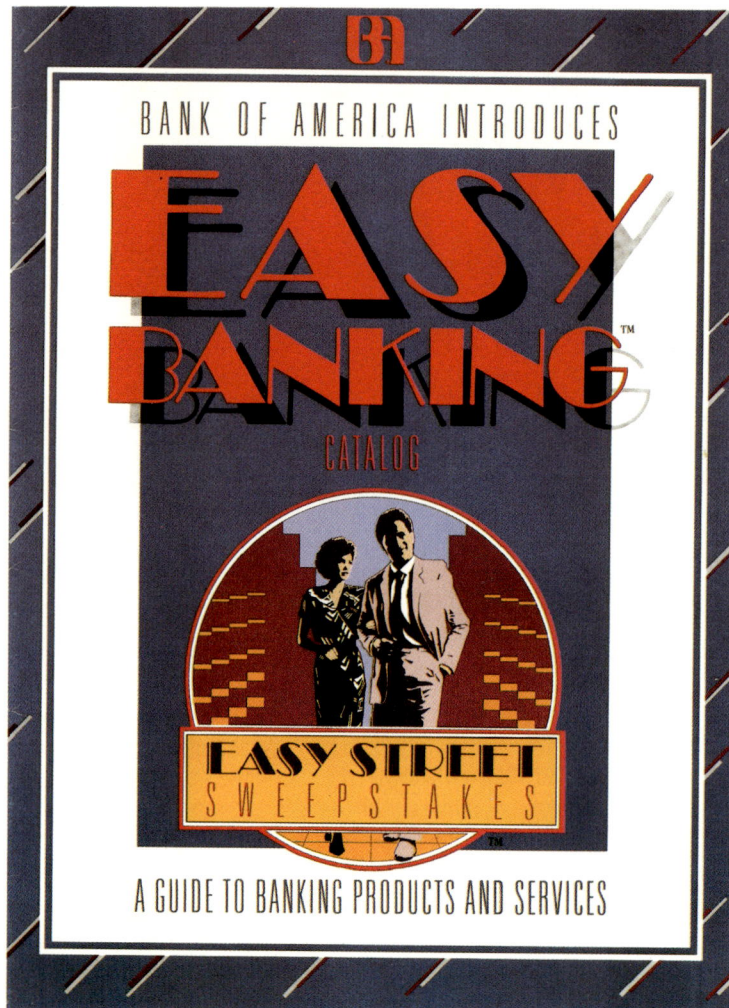

BANK OF AMERICA INTRODUCES

EASY
BANKING™

CATALOG

EASY STREET
SWEEPSTAKES

A GUIDE TO BANKING PRODUCTS AND SERVICES

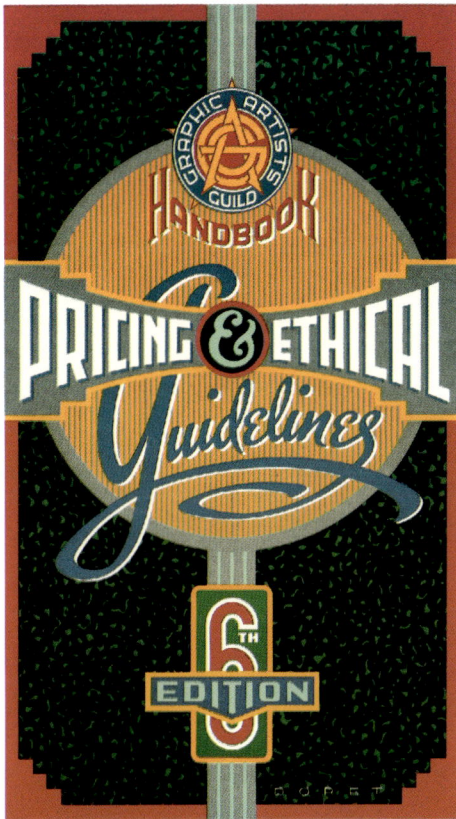

DESIGNER/ILLUSTRATOR: Michael Doret

This decorative, old-fashioned approach does much to take the edge off a title like "Pricing & Ethical Guidelines," and the choice of flat, pure colors makes the design at once easy to read and fun to look at.

CLIENT: Robert B. Fuhrer, Mark Setteducati and David Fuhrer
DESIGNER/ILLUSTRATOR: Michael Doret

Putting this game title into three dimensions, and then suggesting that it's rotating allows the word to be displayed frontward and backward at the same time, adding a visual pun to a literal one. The purple shadowed edges against the dark green seem to add a peculiar glow to the yellow and orange letters. While the color and type choices are as playful as the word itself, this remains a very legible, hard-working package design.

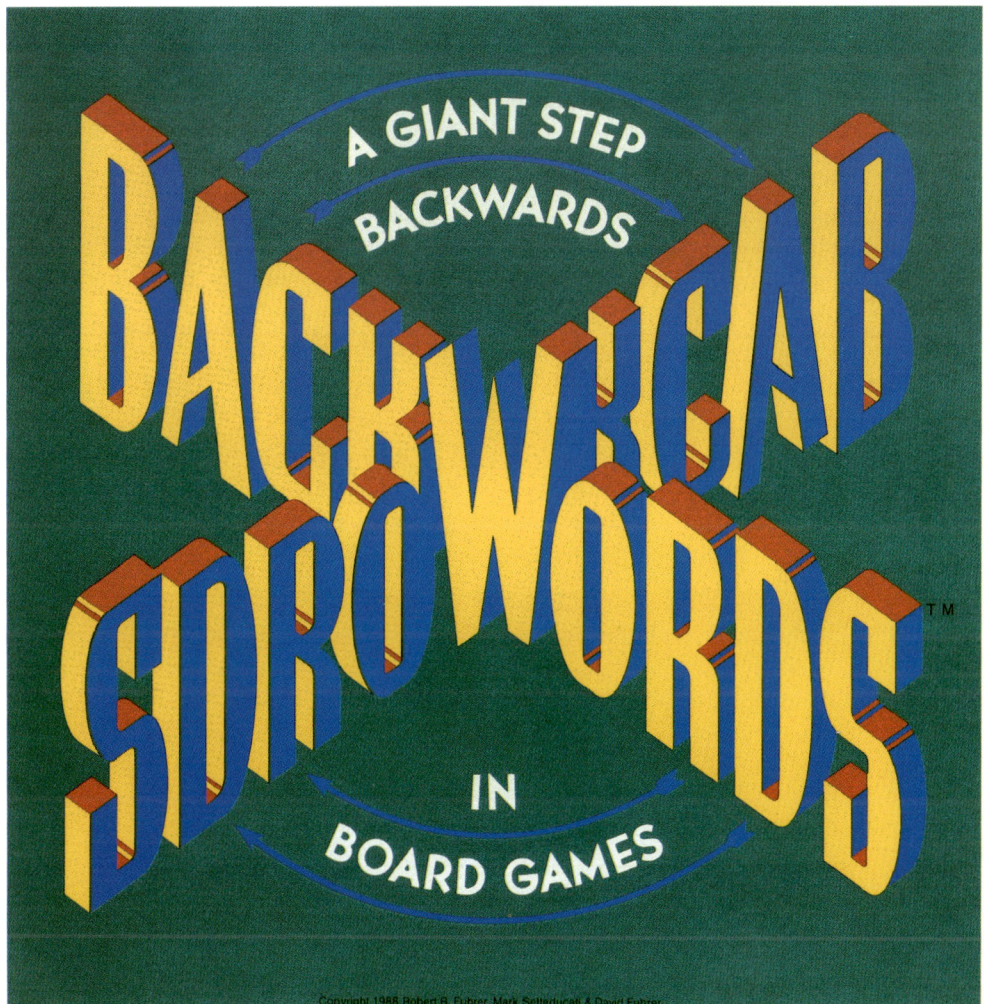

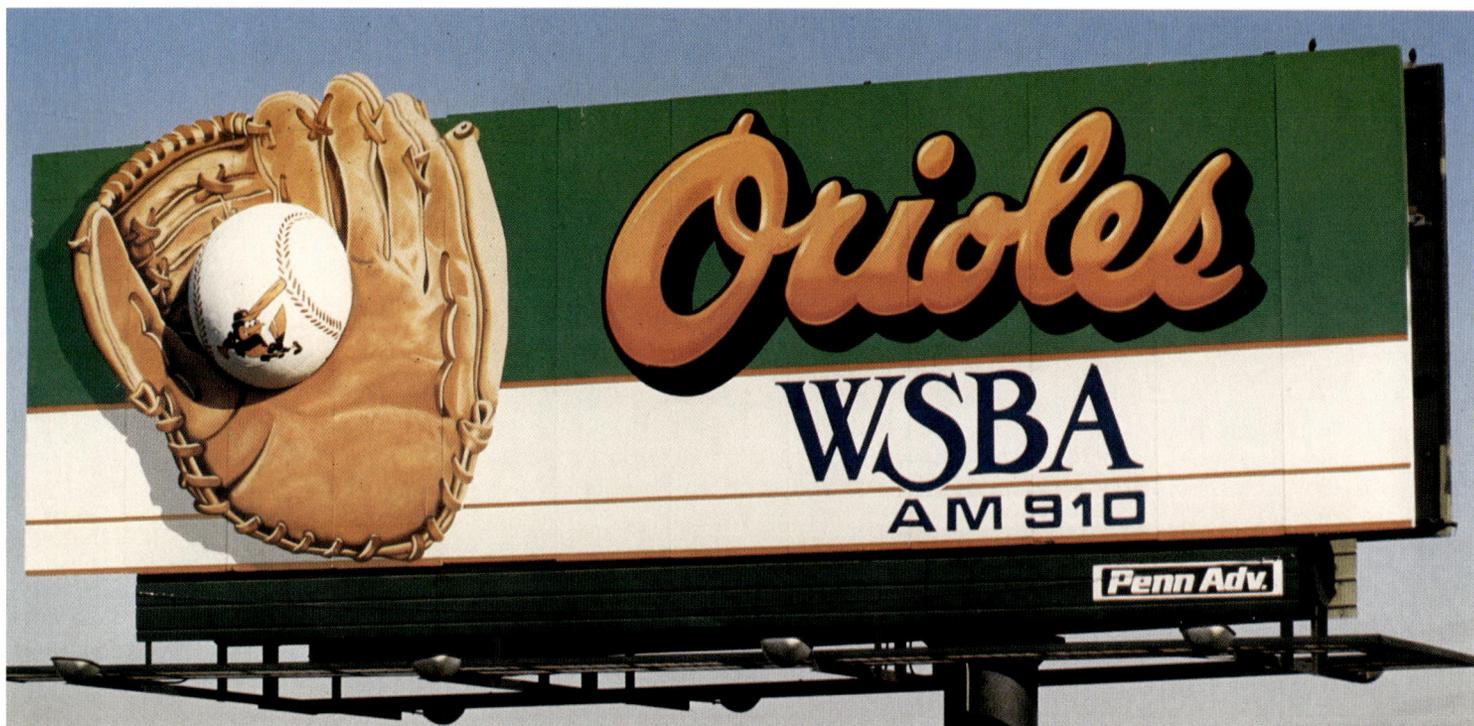

CLIENT: WSBA 910 AM Radio
PRODUCT: Orioles Baseball
AGENCY: Penn Advertising, Inc., York Division
ART DIRECTOR: Mark T. Grab

The slightly softened orange cartoon script popping off a field of grass green says "Baseball" all by itself; nevermind the bright, sunny ball and glove...this whole board looks just like a well tended infield. For a three-word board to work this well, the color and the type have to work together perfectly, and they do.

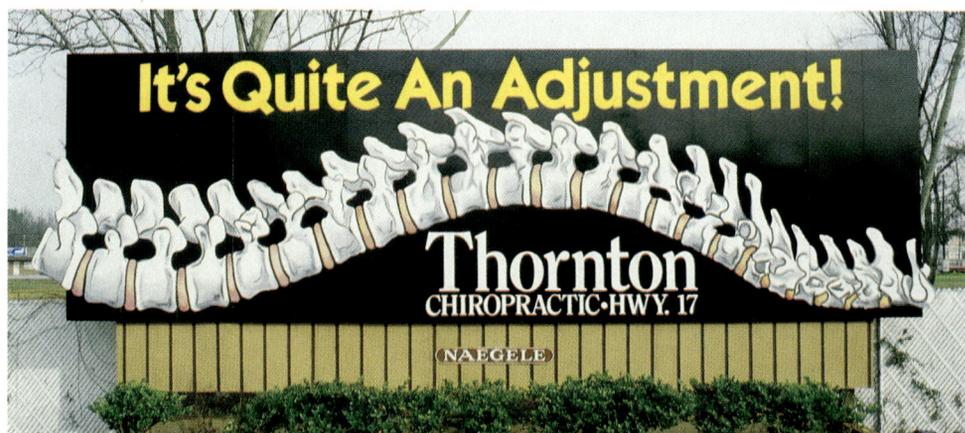

CLIENT: Thornton Chiropractic
AGENCY: Naegele Outdoor Advertising, Inc.
ART DIRECTOR: Kent Powell
PICTORIAL ARTIST: Denick Crenshaw
ACCOUNT EXECUTIVE: Mike Russell

Essentially a three-color design, the type picks up the yellow and white that predominate in the illustration of the spine, and leaves the overall board looking clean, simple and, in spite of the visual theme, inviting. Nothing fancy here in the type to interfere with the pictorial message; just straightforward, legible, very agreeable typography.

CLIENT: Virgin Records/A&M
AGENCY: Design Clinic
ART DIRECTOR: Kenneth Ansell
PHOTOGRAPHY: Gavin Cochrane

A very moody cover photo punctuated by a very unconventional type cluster. Here, the black and white image is teased by the very subtle red and blue lettering that say "PHILIP & GIORGIO." At the same time, the important message is telegraphed to the shopper in a tall yellow gothic..."OAKEY MORODER." Like a kind of tether, the red and blue letters act as the exact opposite of a drop shadow; they keep the yellow words ON the page, and tie it very successfully into this introspective portrait.

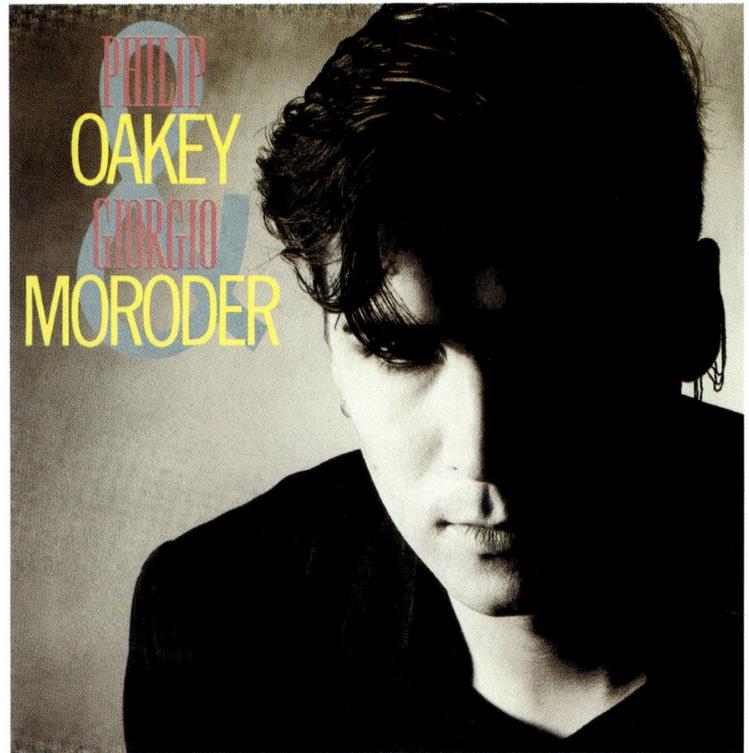

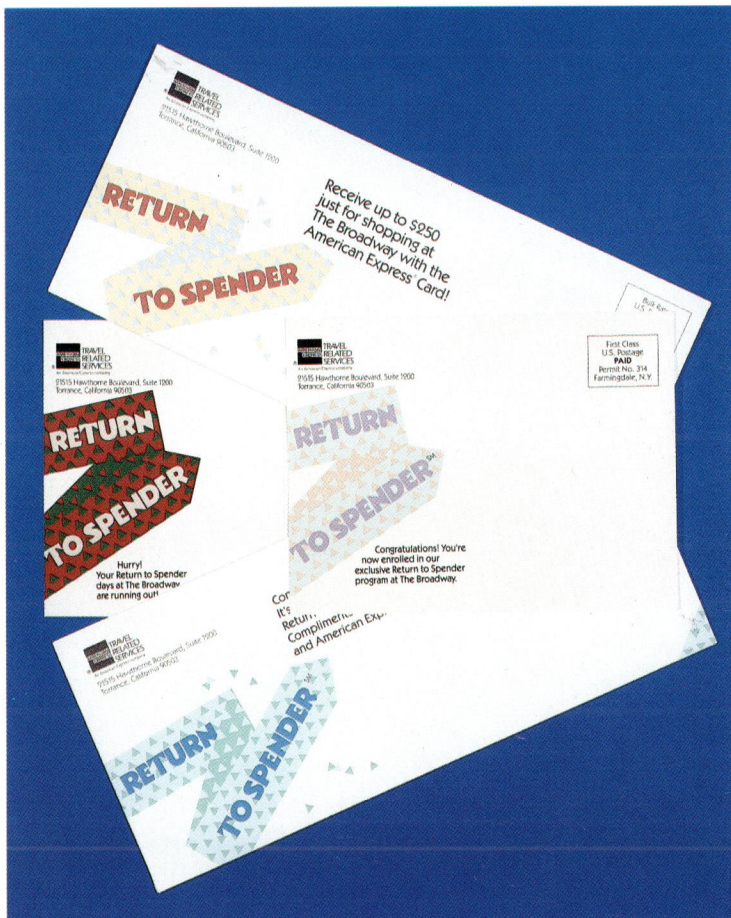

CREATIVE DIRECTOR: Pauline Cabouli
ART DIRECTOR: Myron Polenberg

A direct mail series that relies on the eloquence of color alone to indicate mounting or receding urgency. Beginning with an eye-catching red-orange on yellow, the respondent is rewarded with a relaxing pastel note of thanks. Next, in vibrating red and green, comes a warning that time is running out. And finally, congratulations in a cool harmony of blues and greens suggest end of day, a job well done. While the basic design remains the same to facilitate recognition, the changing colors help to move the story along.

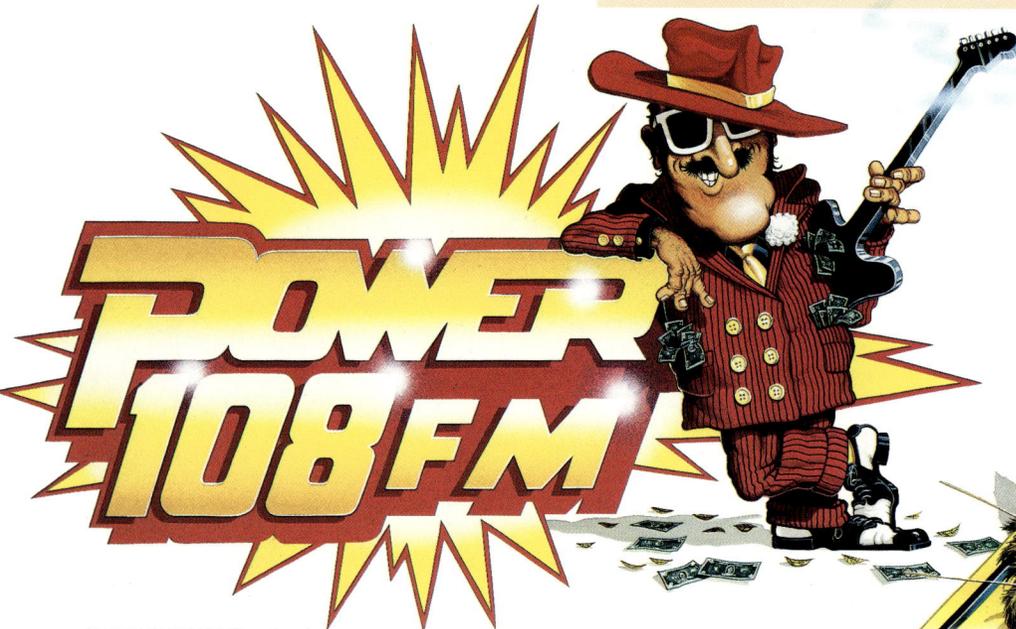

CLIENT: WZOU Radio 94.5, Boston
DESIGNER/ILLUSTRATOR: Scott Ross

The type here looks as though it's having as good a time as its friend, this latter-day Cheshire cat. A fat gothic in yellow on red, with a clever double drop shadow, these call letters glint in a made-up morning sun guaranteed to make you want to tune in on the fun.

CLIENT: WPHR-FM Cleveland
DESIGNER/ILLUSTRATOR: Scott Ross

A zany tough guy in a cartoon almost-zoot suit, bearing a guitar leans nonchalantly on a blazing hot letterpack that seems to draw its glow from the explosion behind it. The letters gleam at the corners, but their real energy comes from the super realistic drop shadow and the white heat that centers between the two lines of type. A slick cartoon that's hard to miss, but easy to smile back at.

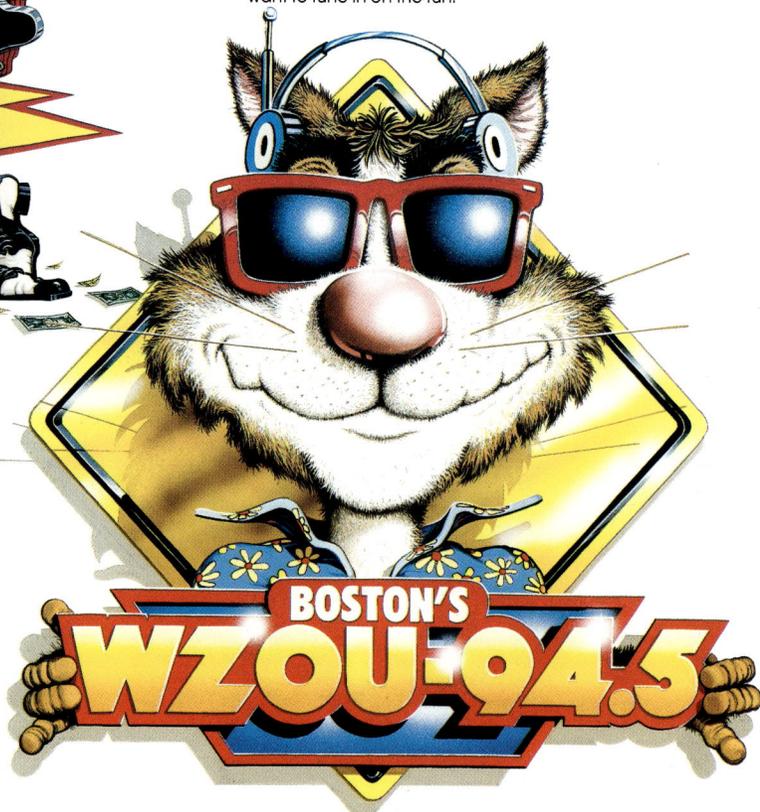

CLIENT: Peridia Golf & Country Club
AGENCY: ARC Advertising
ART DIRECTOR: Connie Mayhew
ILLUSTRATOR: Joseph Hegglin

A logo design reminiscent of Florida the way it was presented in the 30's, 40's and 50's. The pastel aquamarine and flamingo tones harmonize very well to create a sense of laid-back, tropical, civilized hospitality.

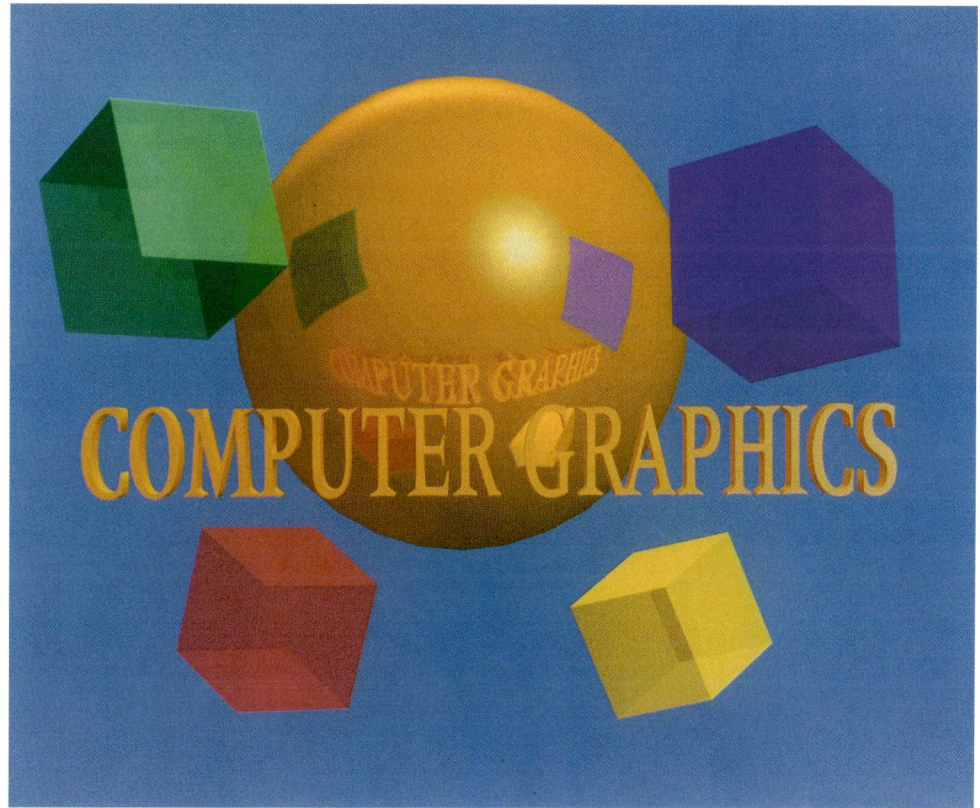

CLIENT: XHG-TV Channel 4, Guadalajara, Mexico
PRODUCT: Station Logo I.D.
MEDIUM: Computer Generated 2D and 3D Graphics
AGENCY: Base Two Computer Graphics, Inc.

Existing only in a computer memory as many thousands of "on-off" commands, this attractive image and many like it would have been impossible only a few years ago. This station logo is a fine example of the subtlety and interest that can now be achieved on a computer in the hands of an experienced and sensitive designer, and shows that regardless of the medium, good design principles and color harmonies will always be essential.

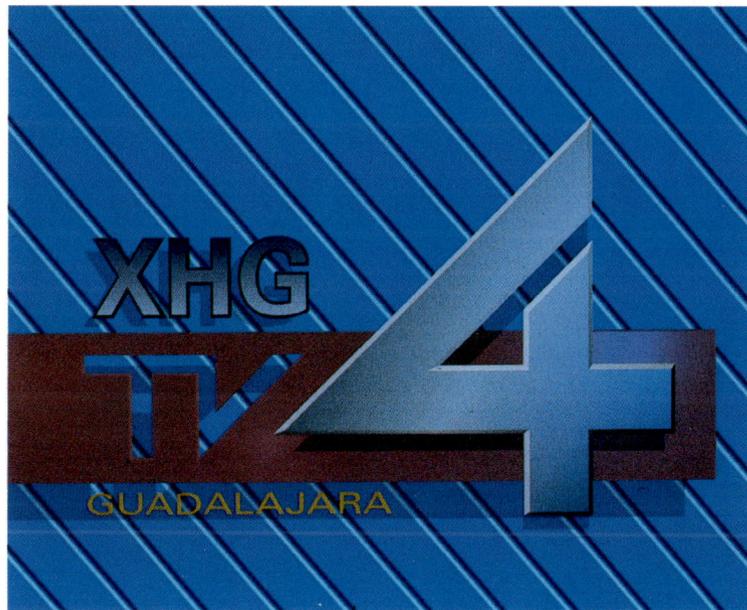

CLIENT: Video Graphic Productions
ART DIRECTOR: James MacGregor

Set in an environment of bright, simple dancing shapes and colors, the intricacy of the three dimensional letters makes this a fun, easy-to-read title. The reflected letters in the golden sphere serve a purpose similar to a drop shadow; they make the title pop almost clear out of the screen. Video adds a major new challenge, and opportunity, in that it happens over time...it is a FOUR dimensional use of type and color.

Creative typography is a
language within a language.
When the eloquence of
color is blended in, whole new
levels of meaning can be added to
the written word.

THEORIES
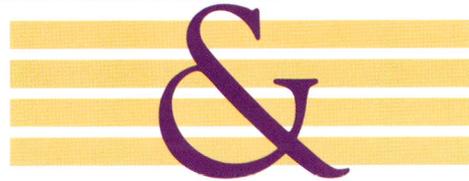
& IDEAS

TYPE COLOR

As Alan Peckolick so aptly pointed out in his essay, a paragraph of type is a textured mass, and so has an impact on any design. As a textured mass instead of a solid form or block, a column of text will appear to the eye lighter or darker, richer or leaner, depending on the nature of the letterforms used. This is what is called "type color", and the designer can take advantage of it in forming the overall character of the page.

These two examples are set in Goudy Oldstyle and in Avant Garde Gothic, the two styles chosen for this book. As you can see, each block of text has its own distinct appearance as a design element, even though the exact same words are used. Without changing anything else, for example, we can alter the density, the "color", of these blocks by merely increasing the line spacing, or leading, by a point or two, or changing the type size slightly. Knowing you can do this kind of

Typography, color and design are the three elements of effective visual communication. You can design using only color, but not using only type. Even black type on white paper constitutes a color relationship. Your choice of typeface, size, spacing and arrangement will determine how well your design works. Your choice of colors will often limit you in selecting and placing your type. None of these elements can be addressed in isolation; they must be dealt with all at once if your design is to be coherent, focused and forceful.

GOUDY OLD STYLE, 10 POINT, 1 POINT LEADING, KERNED

Typography, color and design are the three elements of effective visual communication. You can design using only color, but not using only type. Even black type on white paper constitutes a color relationship. Your choice of typeface, size, spacing and arrangement will determine how well your design works. Your choice of colors will often limit you in selecting and placing your type. None of these elements can be addressed in isolation; they must be dealt with all at once if your design is to be coherent, focused and forceful.

AVANT GARDE BOOK, 10 POINT, 1 POINT LEADING CONDENSED 10%

Once a pleasing texture is achieved in a block of copy, converting it to color that adds to the impact of the overall page is normally just a matter of judgement.

fine tuning will make it easier to arrive at a less rigidly imposed color harmony between your type and background without compromising readability.

A point of interest: Though other design considerations may be overriding, and a competent typesetter can smooth out word spacing in a justified column, consistent and pleasing type color is easier to achieve if the column is set ragged right. This difference becomes more pronounced as the maximum measure decreases…the narrower the column, the more beneficial a ragged right becomes.

While "rivers" and "widows" are bothersome to some designers, they generally do not interfere too much with a good body of text. However, if the problem is a bad one, it can usually be solved by changing the widest measure or typesize a bit if allowed, adding a little extra sentence spacing, or in extreme cases, adjusting the copy a bit.

Once a pleasing texture is achieved in a block of copy, converting it to a color that adds to the impact of the overall page is normally just a matter of judgement. Remember, an orange headline may be perfect for a story on the Chicago fire, but

will the same color in the text add to the effect…or diminish it? Here, only your own imagination, experience and education can help you. So the conclusion is that type color, which is not actually real color, may be all you need to finish off a colorful page.

HEADLINING

Next to the visual, the headline ought to be the most efficient, the most arresting, and the most interesting thing on the page. In fact, in some applications, especially outdoor, it can be the *only* thing on the page. Your headline should carry your message into the communications fray with lightning speed, and used correctly, it can hold your reader's interest long enough to give the full story a chance to be told. Headlines in color are not necessary, but in the competitive world of commercial graphics, every legitimate advantage should be sought. However, color can be a double-edged sword. You want your reader's attention, but simply shouting won't often do the job. Legibility is not shouting. Visibility need not be shouting, though it very frequently is. Your use of color type should do more

than just flag the reader down…it can and should tell part of your story by itself. So use it carefully. When hot and brassy is clearly called for, don't be afraid of it; when cool and subtle carries the message better, don't disdain it. Remember, your headline is there to do two jobs: catch the reader's eye, and then arouse his or her interest in your message.

LETTERFORM AND THE DOT

With the rare exception of areas of solid coverage, all process printing is done with various forms of dot patterns. Sometimes the screen can be mezzotint, line etching, spiral or wavy lines, or whatever, but regardless, when type is set in four-color process, its shape is "digitized", abstracted, into a collection of dots or pure process inks, and some of the perfection of the form is lost. How much is lost is determined directly by the ratio of dot size to letter size. The bigger the dot, the greater the roughness; the smaller the letter, the greater the roughness. For this reason, it's important to think twice before setting very small type in four-color process. Sometimes, of course, if the budget is there, a fifth matching color can

HEADLINES IN COLOR

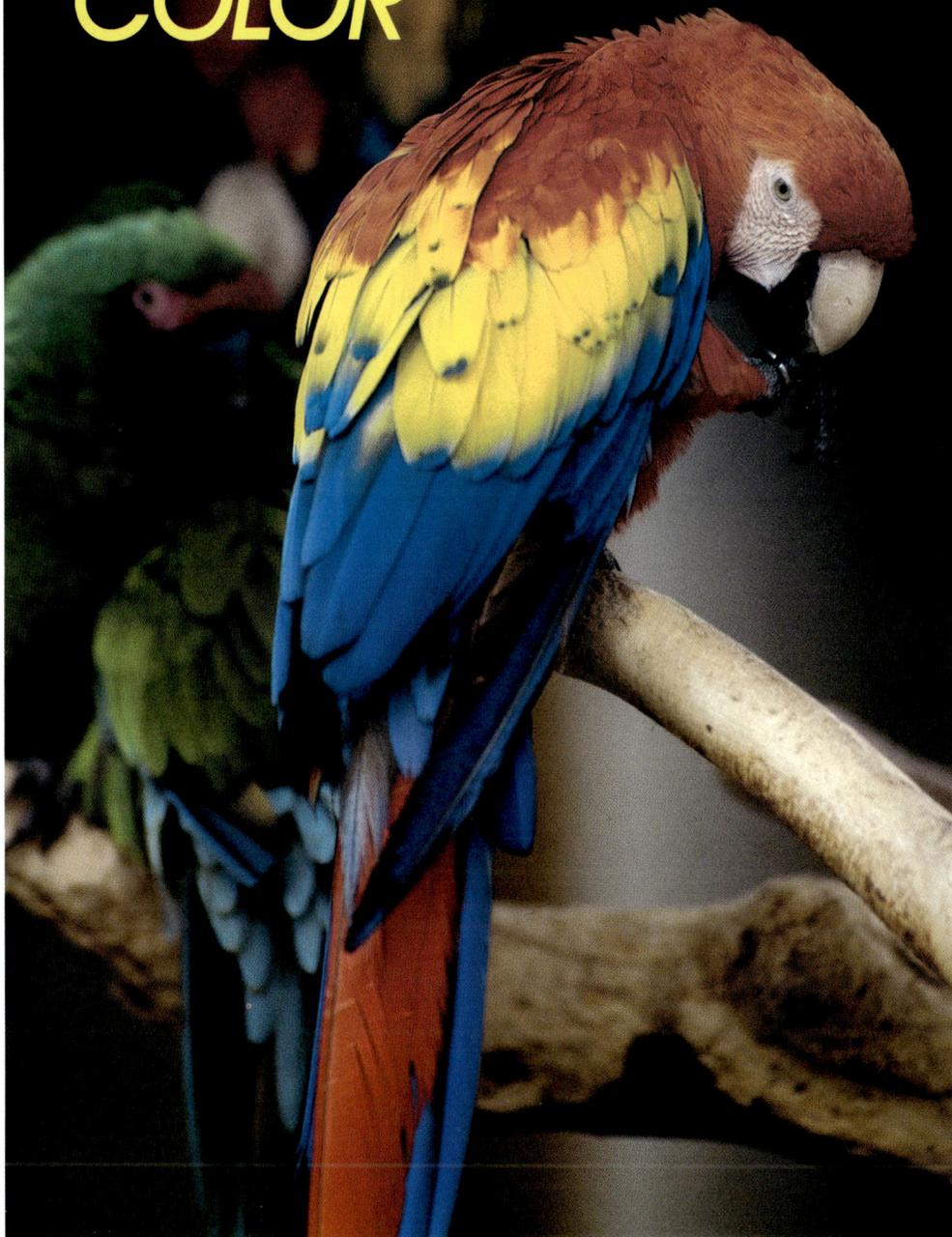

be used as a solid line shot. This is always the best way to set small type in color, although close registration will become more critical. Alternatives to increasing the point size may include setting a slightly bolder font or choosing a color that contrasts more with its background. These approaches will help legibility, but the letter will still be roughened.

A similar problem can arise when reversing very small type out of a four-color background. Perfect registration in four-color is always sought, but not always achieved, and the smaller the letterform, the more damage will be done to its legibility by even a tiny misalignment. This also applies to very thin, light faces, like some of the ultralight fonts in Avant Garde or Futura. The designer may find that instead of white text, the finished job will have type "sort of" in magenta, yellow, cyan or black. Good communications with your printer can help you set smaller or thinner type than might otherwise be safe, but such approaches are always risky and should be undertaken with caution if at all.

PAPERS

Since the surface you put your design on will affect its final character, it's necessary to understand how different papers work with or against different inks and printing techniques. Basically, paper comes in two kinds: uncoated and coated, the latter being the glossy, less absorbent, more expensive variety. Being less absorbent, it can hold a smaller dot, hold it more

If the type is black and the background is white, there's still a background. If either or both are in color, the design gets more interesting.

ILLUSTRATOR: DAN PELAVIN

DROP SHADOWS

This is a technique you can use again and again, and always achieve a different effect, get a different result. When you add a shadow, a dark tone that echoes the letterform below and usually to the right, the letter appears suspended above the surface of the page. If in addition the letter is more brilliant than its background, it really does seem to jump right out into the third dimension. Some drop shadows are subtle; many are not. Most are deep and dramatic, and some, the "Superhero" word-blocks invented by comic book artists, give a feeling of overwhelming mass. But the drop shadow can be more sophisticated. Even, for instance, a minimal shadow can go a long way to improving legibility if the type and background are of similar hue or intensity. Use the drop shadow to create a number of effects: better legibility, lightness when two heavier colors are being used together, or a heavy monumental feeling as in the case of the Biblical movie posters where letters were actually rendered as in tons of sandstone. The drop shadow is a simple, versatile way to bring letterforms into the third dimension, and with very dramatic results.

sharply, and will not intrude its own color into the ink as much. Not all coated stock is white; two or three suppliers offer a colored "dull" coated paper. It is a specialty item, however, and for practical purposes we can say that if you're thinking in terms of coated stock, you're going to be using white. But not all whites are the same. They may range from a soft, almost creamy white to a brilliance that can dazzle the eye. Uncoated stock, of course, comes in any color you care to

order. Depending on the actual stock, however, the color of the paper and the inks you use will affect each other, sometimes with unexpected results. Even in pure white, your color harmonies will emerge on uncoated paper in ways different from what you would get on coated papers. Again, experience is the best teacher, but the tuition can be high. The only rule of thumb that you can rely on here is that the more expensive the paper is, the better your color control will be.

Reversing type out of a four-color background can be done, but the problems begin to multiply as your text gets smaller or thinner.

Pretty soon, holding the letterform against the millions of dots becomes an impossible task.

BACKGROUNDS

Everything you ever set in type will be printed against a background. If the type is black and the background is white, there's still a background. When either or both are in color, the design gets more interesting. When the background starts to get complex, the design can get difficult. The following portion of this book, the Color Selector, will allow you almost boundless opportunities to experiment with type on backgrounds. TYPE & COLOR has provided a large number of color backgrounds, but that's really only scratching the surface.

Headlining over a complex background, like the leaves on a tree or a cityscape, need not be difficult. Keeping in mind the nature of the shapes in the background often helps in choosing a face and color for your headline. For example, those leaves will probably form a motley ground of random, but tiny and somewhat rounded shapes of light and dark greens in the sunlit tree. So you'll probably want to find a contrast to this pattern in shape as well as color. Here a bolder, simpler letterform is called for rather than something highly ornamented or florentine. A gothic typeface printed in a color that contrasts the leaves in either hue or intensity will read easily and not fight with the tree for the eye's attention.

COLOR
SELECTOR

The pages that follow will not make decisions for you, but they will allow you virtually limitless combinations to "shop", or to try out, as you prepare your color work.

Six hundred colors are arranged along the lines of using standard process inks: Cyan, Magenta and Yellow. As you become familiar with these pages, you'll notice the harmonies and relationships that result from a logical arrangement of the process inks. These color bands are designed for use with the collection of clear acetate type chart overlays pocketed inside the back cover. Together, these two subsystems will help you determine at a glance a lot more than just "which color looks nice with which".

Each overlay is printed in two opaque colors, each color displaying four distinct typefaces in three sizes. By laying any of the ten color/type acetates over any of the printed color backgrounds, you can see the effects of more than 800,000 possible variations. One of the overlays contains, in addition to a black and a white type specimen, a gray scale of screened black in six densities. This allows you to add black to any other combination in the book, from 70% down to 10%.

Because the book is printed in four color process, some of the bright colors in other color matching systems cannot be reproduced exactly. However, any of the acetate type overlays can be used with any system. In fact, this system should be integrated into your overall color library. Don't hesitate to include your own artwork or original photography. The possibilities are truly endless.

The pages of color bands start off with the pure process inks: Black, Cyan, Magenta and Yellow, followed by the six-color spectrum of primary and secondary colors. This is somewhat subjective, but the colors are Orange, Red, Violet, Blue and Green. Yellow is the only color that is the same in both process and the spectrum used in this book.

From this point on, the colors are arranged in a logical progression of process ink combinations. Gradations appear from page to page within each grouping horizontally. Vertically within each page, however, the color harmonies emerge from the logic of the ink combinations.

While we've limited our chosen colors to six hundred, this still gives you plenty of room to experiment and be creative. Use TYPE & COLOR freely and often to test, invent, and design.

TYPE & COLOR

The first four pages of the Color Selector show the four process colors, each ranging from 100% to 5%, except for Yellow, which, due to its light value, is decreased to 10%. Yellow is the one process color that remains the same in the spectrum of "true" colors.

100% BLACK

80% BLACK

60% BLACK

40% BLACK

20% BLACK

5% BLACK

100% CYAN

80% CYAN

60% CYAN

40% CYAN

20% CYAN

5% CYAN

100% MAGENTA

80% MAGENTA

60% MAGENTA

40% MAGENTA

20% MAGENTA

5% MAGENTA

TYPE & COLOR

This page ends the series of pure process inks with Yellow, and begins the series of "true" spectrum colors with the same Yellow. The idea of a "true" color is a subjective one. The colors on Pages 56 through 60 are blends of the process inks that give us these subjective colors: Orange, red, violet, blue and green.

100% YELLOW

80% YELLOW

60% YELLOW

40% YELLOW

20% YELLOW

10% YELLOW

50% MAGENTA / 90% YELLOW

40% MAGENTA / 80% YELLOW

30% MAGENTA / 70% YELLOW

20% MAGENTA / 60% YELLOW

10% MAGENTA / 50% YELLOW

5% MAGENTA / 40% YELLOW

90% MAGENTA / 70% YELLOW

80% MAGENTA / 60% YELLOW

70% MAGENTA / 50% YELLOW

60% MAGENTA / 40% YELLOW

50% MAGENTA / 30% YELLOW

40% MAGENTA / 20% YELLOW

50% CYAN / 80% MAGENTA

40% CYAN / 70% MAGENTA

30% CYAN / 60% MAGENTA

20% CYAN / 50% MAGENTA

10% CYAN / 40% MAGENTA

5% CYAN / 30% MAGENTA

100% CYAN / 50% MAGENTA

90% CYAN / 40% MAGENTA

80% CYAN / 30% MAGENTA

70% CYAN / 20% MAGENTA

60% CYAN / 10% MAGENTA

50% CYAN / 5% MAGENTA

80% CYAN / 80% YELLOW

70% CYAN / 70% YELLOW

60% CYAN / 60% YELLOW

50% CYAN / 50% YELLOW

40% CYAN / 40% YELLOW

30% CYAN / 30% YELLOW

2-COLOR COMBINATIONS

10% MAGENTA / 100% YELLOW

10% MAGENTA / 80% YELLOW

10% MAGENTA / 60% YELLOW

10% MAGENTA / 40% YELLOW

10% MAGENTA / 20% YELLOW

10% MAGENTA / 5% YELLOW

Here begins a larger sequence of colors made up of varying combinations of two process inks. On the first five pages are colors where Magenta remains constant while Yellow decreases in intensity within each page. The underlying constant color on each page (in this case, 10% Magenta) is shown in the smaller color bars above and below.

Within this sequence (Pages 61 through 65) there is a very interesting progression from warm, vibrant yellow-oranges to cool vibrant reds at the end. The warmer and cooler colors within this group make some interesting combinations, as can be seen in the headline on Page 63.

30% MAGENTA / 100% YELLOW

30% MAGENTA / 80% YELLOW

30% MAGENTA / 60% YELLOW

30% MAGENTA / 40% YELLOW

30% MAGENTA / 20% YELLOW

30% MAGENTA / 5% YELLOW

You will find that the bottom color in each group of six colors forms the undertone for the entire page.

Typography, Color & Design

50% MAGENTA / 100% YELLOW

50% MAGENTA / 80% YELLOW

50% MAGENTA / 60% YELLOW

50% MAGENTA / 40% YELLOW

50% MAGENTA / 20% YELLOW

50% MAGENTA / 5% YELLOW

Where interesting combinations exist between colors on a page or within a group of related pages, sample headlines are provided.

70% MAGENTA / 100% YELLOW

70% MAGENTA / 80% YELLOW

70% MAGENTA / 60% YELLOW

70% MAGENTA / 40% YELLOW

70% MAGENTA / 20% YELLOW

70% MAGENTA / 5% YELLOW

90% MAGENTA / 100% YELLOW

90% MAGENTA / 80% YELLOW

90% MAGENTA / 60% YELLOW

90% MAGENTA / 40% YELLOW

90% MAGENTA / 20% YELLOW

90% MAGENTA / 5% YELLOW

On the following five pages, Yellow is the constant on each page, and Magenta varies.

The progression from these warm vibrant reds and oranges to the cool peach and violet reds on Page 70 is particularly beautiful. This series suggests the many colors seen at sunrise and sunset.

100% MAGENTA / 90% YELLOW

80% MAGENTA / 90% YELLOW

60% MAGENTA / 90% YELLOW

40% MAGENTA / 90% YELLOW

20% MAGENTA / 90% YELLOW

5% MAGENTA / 90% YELLOW

Typography, Color & Design

100% MAGENTA / 70% YELLOW

80% MAGENTA / 70% YELLOW

60% MAGENTA / 70% YELLOW

40% MAGENTA / 70% YELLOW

20% MAGENTA / 70% YELLOW

5% MAGENTA / 70% YELLOW

The hot yellow headline over the red background shown above says FIRE! Excellent for conveying everything from danger to temptation. A tempting color sequence to use, but one that could be "dangerous" as well.

100% MAGENTA / 50% YELLOW

80% MAGENTA / 50% YELLOW

60% MAGENTA / 50% YELLOW

40% MAGENTA / 50% YELLOW

20% MAGENTA / 50% YELLOW

5% MAGENTA / 50% YELLOW

100% MAGENTA / 30% YELLOW

80% MAGENTA / 30% YELLOW

60% MAGENTA / 30% YELLOW

40% MAGENTA / 30% YELLOW

20% MAGENTA / 30% YELLOW

5% MAGENTA / 30% YELLOW

TYPE & COLOR

The coral colors, 60% Magenta/10% Yellow,
and 40% Magenta/10% Yellow on this page
are very fashionable, especially in women's
cosmetics.

100% MAGENTA / 10% YELLOW

80% MAGENTA / 10% YELLOW

60% MAGENTA / 10% YELLOW

40% MAGENTA / 10% YELLOW

20% MAGENTA / 10% YELLOW

5% MAGENTA / 10% YELLOW

TYPE & COLOR

On Pages 71 through 74, Cyan is the constant color, while Magenta decreases, top to bottom.

5% CYAN / 100% MAGENTA

5% CYAN / 80% MAGENTA

5% CYAN / 60% MAGENTA

5% CYAN / 40% MAGENTA

5% CYAN / 20% MAGENTA

5% CYAN / 5% MAGENTA

On these pages, the sequence running from the cool reds on Page 71 to the relatively warm blues and violets on Page 74, and the neutral lavenders on Page 72 shares a quality reminiscent of Art Deco, especially in the lighter shades.

20% CYAN / 100% MAGENTA

20% CYAN / 80% MAGENTA

20% CYAN / 60% MAGENTA

20% CYAN / 40% MAGENTA

20% CYAN / 20% MAGENTA

20% CYAN / 5% MAGENTA

In this sequence the top two colors on each page are very similar due to the fugitive quality of Cyan.

40% CYAN / 100% MAGENTA

40% CYAN / 80% MAGENTA

40% CYAN / 60% MAGENTA

40% CYAN / 40% MAGENTA

40% CYAN / 20% MAGENTA

40% CYAN / 5% MAGENTA

60% CYAN / 100% MAGENTA

60% CYAN / 80% MAGENTA

60% CYAN / 60% MAGENTA

60% CYAN / 40% MAGENTA

60% CYAN / 20% MAGENTA

60% CYAN / 5% MAGENTA

Here through Page 78, Magenta is again the constant and Cyan is the variable.

100% CYAN / 70% MAGENTA

80% CYAN / 70% MAGENTA

60% CYAN / 70% MAGENTA

40% CYAN / 70% MAGENTA

20% CYAN / 70% MAGENTA

5% CYAN / 70% MAGENTA

Due to the overall increase in the density of these colors, this series conveys a richer feeling than the previous group, and has an opaline, gemlike quality. The warmer and cooler colors in this group would make for some very interesting, subtle relationships.

100% CYAN / 50% MAGENTA

80% CYAN / 50% MAGENTA

60% CYAN / 50% MAGENTA

40% CYAN / 50% MAGENTA

20% CYAN / 50% MAGENTA

5% CYAN / 50% MAGENTA

Typography, Color & Design

100% CYAN / 30% MAGENTA

80% CYAN / 30% MAGENTA

60% CYAN / 30% MAGENTA

40% CYAN / 30% MAGENTA

20% CYAN / 30% MAGENTA

5% CYAN / 30% MAGENTA

100% CYAN / 10% MAGENTA

80% CYAN / 10% MAGENTA

60% CYAN / 10% MAGENTA

40% CYAN / 10% MAGENTA

20% CYAN / 10% MAGENTA

5% CYAN / 10% MAGENTA

TYPE & COLOR

The next five pages show Yellow as the constant, with Cyan the variable.

The progression from turquoise blue to yellow-green conjures a strong citrus feeling...tangy lemons and limes, avocados and so on.

100% CYAN / 10% YELLOW

80% CYAN / 10% YELLOW

60% CYAN / 10% YELLOW

40% CYAN / 10% YELLOW

20% CYAN / 10% YELLOW

5% CYAN / 10% YELLOW

100% CYAN / 30% YELLOW

80% CYAN / 30% YELLOW

60% CYAN / 30% YELLOW

40% CYAN / 30% YELLOW

20% CYAN / 30% YELLOW

5% CYAN / 30% YELLOW

Typography, Color & Design

100% CYAN / 50% YELLOW

80% CYAN / 50% YELLOW

60% CYAN / 50% YELLOW

40% CYAN / 50% YELLOW

20% CYAN / 50% YELLOW

5% CYAN / 50% YELLOW

The deep forest green above serves as a great leafy background for the brighter, sunnier yellow-green headline.

100% CYAN / 70% YELLOW

80% CYAN / 70% YELLOW

60% CYAN / 70% YELLOW

40% CYAN / 70% YELLOW

20% CYAN / 70% YELLOW

5% CYAN / 70% YELLOW

Typography, Color & Design

100% CYAN / 90% YELLOW

80% CYAN / 90% YELLOW

60% CYAN / 90% YELLOW

40% CYAN / 90% YELLOW

20% CYAN / 90% YELLOW

5% CYAN / 90% YELLOW

Here the yellow-green is richer and makes a good background for the slightly more citrus-looking green headline.

Now the situation is reversed, and through Page 88, Cyan is the constant color, with Yellow decreasing in strength.

This entire sequence is very closely related to the colors of summer.

90% CYAN / 100% YELLOW

90% CYAN / 80% YELLOW

90% CYAN / 60% YELLOW

90% CYAN / 40% YELLOW

90% CYAN / 20% YELLOW

90% CYAN / 5% YELLOW

70% CYAN / 100% YELLOW

70% CYAN / 80% YELLOW

70% CYAN / 60% YELLOW

70% CYAN / 40% YELLOW

70% CYAN / 20% YELLOW

70% CYAN / 5% YELLOW

50% CYAN / 100% YELLOW

50% CYAN / 80% YELLOW

50% CYAN / 60% YELLOW

50% CYAN / 40% YELLOW

50% CYAN / 20% YELLOW

50% CYAN / 5% YELLOW

30% CYAN / 100% YELLOW

30% CYAN / 80% YELLOW

30% CYAN / 60% YELLOW

30% CYAN / 40% YELLOW

30% CYAN / 20% YELLOW

30% CYAN / 5% YELLOW

10% CYAN / 100% YELLOW

10% CYAN / 80% YELLOW

10% CYAN / 60% YELLOW

10% CYAN / 40% YELLOW

10% CYAN / 20% YELLOW

10% CYAN / 5% YELLOW

3-COLOR COMBINATIONS

10% CYAN / 5% MAGENTA / 100% YELLOW

10% CYAN / 5% MAGENTA / 80% YELLOW

10% CYAN / 5% MAGENTA / 60% YELLOW

10% CYAN / 5% MAGENTA / 40% YELLOW

10% CYAN / 5% MAGENTA / 20% YELLOW

10% CYAN / 5% MAGENTA / 5% YELLOW

This begins the section of combinations of three inks, Cyan, Magenta and Yellow. On each page, two colors will be constants, and one variable.

Here through Page 93, the two inks that will be constant on each page are Cyan and Magenta. Yellow is the variable color.

The gradation of these colors is tighter than in previous groups. Especially close are the first three colors on each page, but nevertheless, the logic of the formulas does hold up.

10% CYAN / 20% MAGENTA / 100% YELLOW

10% CYAN / 20% MAGENTA / 80% YELLOW

10% CYAN / 20% MAGENTA / 60% YELLOW

10% CYAN / 20% MAGENTA / 40% YELLOW

10% CYAN / 20% MAGENTA / 20% YELLOW

10% CYAN / 20% MAGENTA / 5% YELLOW

This series shows a very fine relationship between the warm sides of red, orange and yellow in the moderately intense range.

10% CYAN / 40% MAGENTA / 100% YELLOW

10% CYAN / 40% MAGENTA / 80% YELLOW

10% CYAN / 40% MAGENTA / 60% YELLOW

10% CYAN / 40% MAGENTA / 40% YELLOW

10% CYAN / 40% MAGENTA / 20% YELLOW

10% CYAN / 40% MAGENTA / 5% YELLOW

Beginning on Page 89, the two constant tints
in every color bar are shown at the top and
bottom of each page.

Here, the constants are: 10% Cyan (above)
and 40% Magenta (below)

10% CYAN / 60% MAGENTA / 100% YELLOW

10% CYAN / 60% MAGENTA / 80% YELLOW

10% CYAN / 60% MAGENTA / 60% YELLOW

10% CYAN / 60% MAGENTA / 40% YELLOW

10% CYAN / 60% MAGENTA / 20% YELLOW

10% CYAN / 60% MAGENTA / 5% YELLOW

10% CYAN / 80% MAGENTA / 100% YELLOW

10% CYAN / 80% MAGENTA / 80% YELLOW

10% CYAN / 80% MAGENTA / 60% YELLOW

10% CYAN / 80% MAGENTA / 40% YELLOW

10% CYAN / 80% MAGENTA / 20% YELLOW

10% CYAN / 80% MAGENTA / 5% YELLOW

On the next five pages, Cyan and Yellow are the constants, with Magenta the variable.

10% CYAN / 100% MAGENTA / 90% YELLOW

10% CYAN / 80% MAGENTA / 90% YELLOW

10% CYAN / 60% MAGENTA / 90% YELLOW

10% CYAN / 40% MAGENTA / 90% YELLOW

10% CYAN / 20% MAGENTA / 90% YELLOW

10% CYAN / 5% MAGENTA / 90% YELLOW

This entire sequence has an interesting shift from the strong reds at the top to the greenish-yellows at the bottom, and it projects a fruity feeling, with strawberry colors at the end, with peachy colors and candy apple red as on Page 97.

10% CYAN / 100% MAGENTA / 70% YELLOW

10% CYAN / 80% MAGENTA / 70% YELLOW

10% CYAN / 60% MAGENTA / 70% YELLOW

10% CYAN / 40% MAGENTA / 70% YELLOW

10% CYAN / 20% MAGENTA / 70% YELLOW

10% CYAN / 5% MAGENTA / 70% YELLOW

10% CYAN / 100% MAGENTA / 50% YELLOW

10% CYAN / 80% MAGENTA / 50% YELLOW

10% CYAN / 60% MAGENTA / 50% YELLOW

10% CYAN / 40% MAGENTA / 50% YELLOW

10% CYAN / 20% MAGENTA / 50% YELLOW

10% CYAN / 5% MAGENTA / 50% YELLOW

Typography, Color & Design

10% CYAN / 100% MAGENTA / 30% YELLOW

10% CYAN / 80% MAGENTA / 30% YELLOW

10% CYAN / 60% MAGENTA / 30% YELLOW

10% CYAN / 40% MAGENTA / 30% YELLOW

10% CYAN / 20% MAGENTA / 30% YELLOW

10% CYAN / 5% MAGENTA / 30% YELLOW

The soft, sandstone-like colors, as at the end of page 98, work well with the stronger reds and oranges in the middle of this sequence.

10% CYAN / 100% MAGENTA / 10% YELLOW

10% CYAN / 80% MAGENTA / 10% YELLOW

10% CYAN / 60% MAGENTA / 10% YELLOW

10% CYAN / 40% MAGENTA / 10% YELLOW

10% CYAN / 20% MAGENTA / 10% YELLOW

10% CYAN / 5% MAGENTA / 10% YELLOW

On Pages 99 through 103, Cyan remains a constant 30% throughout, Yellow remains constant on each page and Magenta is the variable.

30% CYAN / 100% MAGENTA / 10% YELLOW

30% CYAN / 80% MAGENTA / 10% YELLOW

30% CYAN / 60% MAGENTA / 10% YELLOW

30% CYAN / 40% MAGENTA / 10% YELLOW

30% CYAN / 20% MAGENTA / 10% YELLOW

30% CYAN / 5% MAGENTA / 10% YELLOW

Through this sequence it is interesting to see the effect of the overall 30% Cyan as the Magenta decreases and the colors cool down toward the bottom of each page. Because of the more equal (balanced) formulas that produce colors of a median intensity and value, this range reflects the natural earth and foliage colors of everyday life.

30% CYAN / 100% MAGENTA / 30% YELLOW

30% CYAN / 80% MAGENTA / 30% YELLOW

30% CYAN / 60% MAGENTA / 30% YELLOW

30% CYAN / 40% MAGENTA / 30% YELLOW

30% CYAN / 20% MAGENTA / 30% YELLOW

30% CYAN / 5% MAGENTA / 30% YELLOW

Typography, Color & Design

30% CYAN / 100% MAGENTA / 50% YELLOW

30% CYAN / 80% MAGENTA / 50% YELLOW

30% CYAN / 60% MAGENTA / 50% YELLOW

30% CYAN / 40% MAGENTA / 50% YELLOW

30% CYAN / 20% MAGENTA / 50% YELLOW

30% CYAN / 5% MAGENTA / 50% YELLOW

30% CYAN / 100% MAGENTA / 70% YELLOW

30% CYAN / 80% MAGENTA / 70% YELLOW

30% CYAN / 60% MAGENTA / 70% YELLOW

30% CYAN / 40% MAGENTA / 70% YELLOW

30% CYAN / 20% MAGENTA / 70% YELLOW

30% CYAN / 5% MAGENTA / 70% YELLOW

Typography, Color & Design

30% CYAN / 100% MAGENTA / 90% YELLOW

30% CYAN / 80% MAGENTA / 90% YELLOW

30% CYAN / 60% MAGENTA / 90% YELLOW

30% CYAN / 40% MAGENTA / 90% YELLOW

30% CYAN / 20% MAGENTA / 90% YELLOW

30% CYAN / 5% MAGENTA / 90% YELLOW

In this headline, the green looks somewhat more acid, and plays well off the richer red from the top of the page.

Here through Page 108, Cyan is again a constant 30% throughout, but Magenta becomes the second, page-to-page, constant color, and Yellow varies.

30% CYAN / 80% MAGENTA / 100% YELLOW

30% CYAN / 80% MAGENTA / 80% YELLOW

30% CYAN / 80% MAGENTA / 60% YELLOW

30% CYAN / 80% MAGENTA / 40% YELLOW

30% CYAN / 80% MAGENTA / 20% YELLOW

30% CYAN / 80% MAGENTA / 5% YELLOW

This entire sequence contains a wide range of colors in a very natural, balanced framework. These are everyday colors with close natural relationships. The possibilities for different combinations of colors within this sequence are limited only by the artist's own imagination.

30% CYAN / 60% MAGENTA / 100% YELLOW

30% CYAN / 60% MAGENTA / 80% YELLOW

30% CYAN / 60% MAGENTA / 60% YELLOW

30% CYAN / 60% MAGENTA / 40% YELLOW

30% CYAN / 60% MAGENTA / 20% YELLOW

30% CYAN / 60% MAGENTA / 5% YELLOW

30% CYAN / 40% MAGENTA / 100% YELLOW

30% CYAN / 40% MAGENTA / 80% YELLOW

30% CYAN / 40% MAGENTA / 60% YELLOW

30% CYAN / 40% MAGENTA / 40% YELLOW

30% CYAN / 40% MAGENTA / 20% YELLOW

30% CYAN / 40% MAGENTA / 5% YELLOW

30% CYAN / 20% MAGENTA / 100% YELLOW

30% CYAN / 20% MAGENTA / 80% YELLOW

30% CYAN / 20% MAGENTA / 60% YELLOW

30% CYAN / 20% MAGENTA / 40% YELLOW

30% CYAN / 20% MAGENTA / 20% YELLOW

30% CYAN / 20% MAGENTA / 5% YELLOW

30% CYAN / 5% MAGENTA / 100% YELLOW

30% CYAN / 5% MAGENTA / 80% YELLOW

30% CYAN / 5% MAGENTA / 60% YELLOW

30% CYAN / 5% MAGENTA / 40% YELLOW

30% CYAN / 5% MAGENTA / 20% YELLOW

30% CYAN / 5% MAGENTA / 5% YELLOW

On Pages 109 through 111, Cyan is a constant 50% density, while Magenta remains constant within each page, and Yellow is again the variable.

50% CYAN / 5% MAGENTA / 100% YELLOW

50% CYAN / 5% MAGENTA / 80% YELLOW

50% CYAN / 5% MAGENTA / 60% YELLOW

50% CYAN / 5% MAGENTA / 40% YELLOW

50% CYAN / 5% MAGENTA / 20% YELLOW

50% CYAN / 5% MAGENTA / 5% YELLOW

These colors are less intense, some even drab, as in the khaki colors which would make excellent camouflage. However, there is a potential for interesting combinations of adjacent and complementary hues because of the relative equality of value. Of particular interest might be the use of blues with the khaki or violet with some of the greens.

50% CYAN / 20% MAGENTA / 100% YELLOW

50% CYAN / 20% MAGENTA / 80% YELLOW

50% CYAN / 20% MAGENTA / 60% YELLOW

50% CYAN / 20% MAGENTA / 40% YELLOW

50% CYAN / 20% MAGENTA / 20% YELLOW

50% CYAN / 20% MAGENTA / 5% YELLOW

50% CYAN / 40% MAGENTA / 100% YELLOW

50% CYAN / 40% MAGENTA / 80% YELLOW

50% CYAN / 40% MAGENTA / 60% YELLOW

50% CYAN / 40% MAGENTA / 40% YELLOW

50% CYAN / 40% MAGENTA / 20% YELLOW

50% CYAN / 40% MAGENTA / 5% YELLOW

Pages 112 through 114 again show Cyan as a 50% constant, with Yellow constant page-to-page and Magenta the variable color.

50% CYAN / 100% MAGENTA / 50% YELLOW

50% CYAN / 80% MAGENTA / 50% YELLOW

50% CYAN / 60% MAGENTA / 50% YELLOW

50% CYAN / 40% MAGENTA / 50% YELLOW

50% CYAN / 20% MAGENTA / 50% YELLOW

50% CYAN / 5% MAGENTA / 50% YELLOW

These colors once again have a very strong Art Deco feel, and a designer could have a field day even limited to these shades...any combination of two darks and a light, or two lights and a dark from any of these pages has great potential for understated elegance. In short, these are sensationally classy colors.

Typography, Color & Design

50% CYAN / 100% MAGENTA / 30% YELLOW

50% CYAN / 80% MAGENTA / 30% YELLOW

50% CYAN / 60% MAGENTA / 30% YELLOW

50% CYAN / 40% MAGENTA / 30% YELLOW

50% CYAN / 20% MAGENTA / 30% YELLOW

50% CYAN / 5% MAGENTA / 30% YELLOW

Because of the closeness in values on this page you can see that these colors and colors like them will demand a bolder typeface to protect legibility.

50% CYAN / 100% MAGENTA / 10% YELLOW

50% CYAN / 80% MAGENTA / 10% YELLOW

50% CYAN / 60% MAGENTA / 10% YELLOW

50% CYAN / 40% MAGENTA / 10% YELLOW

50% CYAN / 20% MAGENTA / 10% YELLOW

50% CYAN / 5% MAGENTA / 10% YELLOW

Typography, Color & Design

70% CYAN / 100% MAGENTA / 10% YELLOW

70% CYAN / 80% MAGENTA / 10% YELLOW

70% CYAN / 60% MAGENTA / 10% YELLOW

70% CYAN / 40% MAGENTA / 10% YELLOW

70% CYAN / 20% MAGENTA / 10% YELLOW

70% CYAN / 5% MAGENTA / 10% YELLOW

Here through Page 117, Cyan is a constant 70%, with Yellow a constant density page-to-page, and Magenta the variable.

This sequence has extensive potential for play between warm and cool, and light and dark. These colors also have a more passive, melancholy feel than in previous series.

70% CYAN / 100% MAGENTA / 30% YELLOW

70% CYAN / 80% MAGENTA / 30% YELLOW

70% CYAN / 60% MAGENTA / 30% YELLOW

70% CYAN / 40% MAGENTA / 30% YELLOW

70% CYAN / 20% MAGENTA / 30% YELLOW

70% CYAN / 5% MAGENTA / 30% YELLOW

70% CYAN / 100% MAGENTA / 50% YELLOW

70% CYAN / 80% MAGENTA / 50% YELLOW

70% CYAN / 60% MAGENTA / 50% YELLOW

70% CYAN / 40% MAGENTA / 50% YELLOW

70% CYAN / 20% MAGENTA / 50% YELLOW

70% CYAN / 5% MAGENTA / 50% YELLOW

On Pages 118 through 120, Cyan is a constant 70% density, Magenta is a constant on each page and Yellow varies.

70% CYAN / 40% MAGENTA / 100% YELLOW

70% CYAN / 40% MAGENTA / 80% YELLOW

70% CYAN / 40% MAGENTA / 60% YELLOW

70% CYAN / 40% MAGENTA / 40% YELLOW

70% CYAN / 40% MAGENTA / 20% YELLOW

70% CYAN / 40% MAGENTA / 5% YELLOW

This sequence of colors, all closely related by the 70% Cyan undertone, have a distinct feel of water and foliage...almost like the edge of a lake with trees in the background. Dark, shadowy ranges suggestive of water from the Hudson River Valley at the top of Page 118 to Key West at the bottom of Page 120.

70% CYAN / 20% MAGENTA / 100% YELLOW

70% CYAN / 20% MAGENTA / 80% YELLOW

70% CYAN / 20% MAGENTA / 60% YELLOW

70% CYAN / 20% MAGENTA / 40% YELLOW

70% CYAN / 20% MAGENTA / 20% YELLOW

70% CYAN / 20% MAGENTA / 5% YELLOW

70% CYAN / 5% MAGENTA / 100% YELLOW

70% CYAN / 5% MAGENTA / 80% YELLOW

70% CYAN / 5% MAGENTA / 60% YELLOW

70% CYAN / 5% MAGENTA / 40% YELLOW

70% CYAN / 5% MAGENTA / 20% YELLOW

70% CYAN / 5% MAGENTA / 5% YELLOW

Here through Page 123, Cyan is constant at 90%, Magenta is constant page-to-page and Yellow varies.

90% CYAN / 5% MAGENTA / 100% YELLOW

90% CYAN / 5% MAGENTA / 80% YELLOW

90% CYAN / 5% MAGENTA / 60% YELLOW

90% CYAN / 5% MAGENTA / 40% YELLOW

90% CYAN / 5% MAGENTA / 20% YELLOW

90% CYAN / 5% MAGENTA / 5% YELLOW

This sequence, from bright green through sky blue, mossy greens down to ultramarines at the end provides several chances for subdued, tranquil, cool relationships.

90% CYAN / 20% MAGENTA / 100% YELLOW

90% CYAN / 20% MAGENTA / 80% YELLOW

90% CYAN / 20% MAGENTA / 60% YELLOW

90% CYAN / 20% MAGENTA / 40% YELLOW

90% CYAN / 20% MAGENTA / 20% YELLOW

90% CYAN / 20% MAGENTA / 5% YELLOW

90% CYAN / 40% MAGENTA / 100% YELLOW

90% CYAN / 40% MAGENTA / 80% YELLOW

90% CYAN / 40% MAGENTA / 60% YELLOW

90% CYAN / 40% MAGENTA / 40% YELLOW

90% CYAN / 40% MAGENTA / 20% YELLOW

90% CYAN / 40% MAGENTA / 5% YELLOW

Pages 124 through 126 again show Cyan at an overall constant 90%, but with Yellow constant from page-to-page, and Magenta the variable.

90% CYAN / 100% MAGENTA / 50% YELLOW

90% CYAN / 80% MAGENTA / 50% YELLOW

90% CYAN / 60% MAGENTA / 50% YELLOW

90% CYAN / 40% MAGENTA / 50% YELLOW

90% CYAN / 20% MAGENTA / 50% YELLOW

90% CYAN / 5% MAGENTA / 50% YELLOW

The progression here from the very dark, almost neutral, slatelike colors through green, aqua and dark violet to blue is quite subtle. Contrasting the lighter cool colors with the darker warm colors in this group would make very interesting combinations.

90% CYAN / 100% MAGENTA / 30% YELLOW

90% CYAN / 80% MAGENTA / 30% YELLOW

90% CYAN / 60% MAGENTA / 30% YELLOW

90% CYAN / 40% MAGENTA / 30% YELLOW

90% CYAN / 20% MAGENTA / 30% YELLOW

90% CYAN / 5% MAGENTA / 30% YELLOW

90% CYAN / 100% MAGENTA / 10% YELLOW

90% CYAN / 80% MAGENTA / 10% YELLOW

90% CYAN / 60% MAGENTA / 10% YELLOW

90% CYAN / 40% MAGENTA / 10% YELLOW

90% CYAN / 20% MAGENTA / 10% YELLOW

90% CYAN / 5% MAGENTA / 10% YELLOW

Page 127 is unique. Yellow remains constant at 5%, Magenta constant at 60%, and Cyan is the variable color.

100% CYAN / 60% MAGENTA / 5% YELLOW

80% CYAN / 60% MAGENTA / 5% YELLOW

60% CYAN / 60% MAGENTA / 5% YELLOW

40% CYAN / 60% MAGENTA / 5% YELLOW

20% CYAN / 60% MAGENTA / 5% YELLOW

5% CYAN / 60% MAGENTA / 5% YELLOW

From top to bottom it is interesting to note the shift from cool to warm, in three adjacent hues: blue, violet and red...as the Cyan is reduced to reveal at the bottom the common undertone of 5% Cyan, 5% Yellow and 60% Magenta.

Pages 128 through 133 show Magenta as the overall constant density at 40%. Page-to-page, Yellow remains constant and Cyan varies.

100% CYAN / 40% MAGENTA / 5% YELLOW

80% CYAN / 40% MAGENTA / 5% YELLOW

60% CYAN / 40% MAGENTA / 5% YELLOW

40% CYAN / 40% MAGENTA / 5% YELLOW

20% CYAN / 40% MAGENTA / 5% YELLOW

5% CYAN / 40% MAGENTA / 5% YELLOW

This sequence of 36 colors is a perfect example of the color family and harmony theory outlined in George Cawthorn's essay. This family is based on the pink undertones of 5% Cyan/5% Yellow/40% Magenta at the bottom of Page 128. It is interesting how far-reaching the effect of the base tone can be.

Typography, Color & Design

100% CYAN / 40% MAGENTA / 20% YELLOW

80% CYAN / 40% MAGENTA / 20% YELLOW

60% CYAN / 40% MAGENTA / 20% YELLOW

40% CYAN / 40% MAGENTA / 20% YELLOW

20% CYAN / 40% MAGENTA / 20% YELLOW

5% CYAN / 40% MAGENTA / 20% YELLOW

As the Magenta at the bottom of the page warms up, it provides a very classy ground for the slightly more neutral Blue.

100% CYAN / 40% MAGENTA / 40% YELLOW

80% CYAN / 40% MAGENTA / 40% YELLOW

60% CYAN / 40% MAGENTA / 40% YELLOW

40% CYAN / 40% MAGENTA / 40% YELLOW

20% CYAN / 40% MAGENTA / 40% YELLOW

5% CYAN / 40% MAGENTA / 40% YELLOW

100% CYAN / 40% MAGENTA / 60% YELLOW

80% CYAN / 40% MAGENTA / 60% YELLOW

60% CYAN / 40% MAGENTA / 60% YELLOW

40% CYAN / 40% MAGENTA / 60% YELLOW

20% CYAN / 40% MAGENTA / 60% YELLOW

5% CYAN / 40% MAGENTA / 60% YELLOW

100% CYAN / 40% MAGENTA / 80% YELLOW

80% CYAN / 40% MAGENTA / 80% YELLOW

60% CYAN / 40% MAGENTA / 80% YELLOW

40% CYAN / 40% MAGENTA / 80% YELLOW

20% CYAN / 40% MAGENTA / 80% YELLOW

5% CYAN / 40% MAGENTA / 80% YELLOW

Typography, Color & Design

100% CYAN / 40% MAGENTA / 100% YELLOW

80% CYAN / 40% MAGENTA / 100% YELLOW

60% CYAN / 40% MAGENTA / 100% YELLOW

40% CYAN / 40% MAGENTA / 100% YELLOW

20% CYAN / 40% MAGENTA / 100% YELLOW

5% CYAN / 40% MAGENTA / 100% YELLOW

This combination has a settling effect, although the dark green background tends to "militarize" the look a bit.

On Pages 134 through 139, Magenta is an overall constant 20%, Yellow is constant page-to-page and Cyan is the variable.

This group is also a good example of the undertone principle.

100% CYAN / 20% MAGENTA / 100% YELLOW

80% CYAN / 20% MAGENTA / 100% YELLOW

60% CYAN / 20% MAGENTA / 100% YELLOW

40% CYAN / 20% MAGENTA / 100% YELLOW

20% CYAN / 20% MAGENTA / 100% YELLOW

5% CYAN / 20% MAGENTA / 100% YELLOW

All colors in this sequence share the 5% Cyan/5% Yellow/20% Magenta of the last color on Page 139. The range in this case, as opposed to the previous sequence, is lighter and less dense due to the overall 20% reduction in Magenta and is, in the main, cooler and more pastel, especially on Pages 138 and 139.

Typography, Color & Design

100% CYAN / 20% MAGENTA / 80% YELLOW

80% CYAN / 20% MAGENTA / 80% YELLOW

60% CYAN / 20% MAGENTA / 80% YELLOW

40% CYAN / 20% MAGENTA / 80% YELLOW

20% CYAN / 20% MAGENTA / 80% YELLOW

5% CYAN / 20% MAGENTA / 80% YELLOW

This brighter combination is slightly more legible without sacrificing any of the sophistication or harmony seen throughout this sequence.

100% CYAN / 20% MAGENTA / 60% YELLOW

80% CYAN / 20% MAGENTA / 60% YELLOW

60% CYAN / 20% MAGENTA / 60% YELLOW

40% CYAN / 20% MAGENTA / 60% YELLOW

20% CYAN / 20% MAGENTA / 60% YELLOW

5% CYAN / 20% MAGENTA / 60% YELLOW

100% CYAN / 20% MAGENTA / 40% YELLOW

80% CYAN / 20% MAGENTA / 40% YELLOW

60% CYAN / 20% MAGENTA / 40% YELLOW

40% CYAN / 20% MAGENTA / 40% YELLOW

20% CYAN / 20% MAGENTA / 40% YELLOW

5% CYAN / 20% MAGENTA / 40% YELLOW

100% CYAN / 20% MAGENTA / 20% YELLOW

80% CYAN / 20% MAGENTA / 20% YELLOW

60% CYAN / 20% MAGENTA / 20% YELLOW

40% CYAN / 20% MAGENTA / 20% YELLOW

20% CYAN / 20% MAGENTA / 20% YELLOW

5% CYAN / 20% MAGENTA / 20% YELLOW

100% CYAN / 20% MAGENTA / 5% YELLOW

80% CYAN / 20% MAGENTA / 5% YELLOW

60% CYAN / 20% MAGENTA / 5% YELLOW

40% CYAN / 20% MAGENTA / 5% YELLOW

20% CYAN / 20% MAGENTA / 5% YELLOW

5% CYAN / 20% MAGENTA / 5% YELLOW

TYPE & COLOR

Here through Page 145, Magenta is always
5%, Yellow remains constant page-to-page
and Cyan varies. The effect of the common
color, 5% Magenta/5% Yellow/5% Cyan here
is reduced due to its weakness.

100% CYAN / 5% MAGENTA / 5% YELLOW

80% CYAN / 5% MAGENTA / 5% YELLOW

60% CYAN / 5% MAGENTA / 5% YELLOW

40% CYAN / 5% MAGENTA / 5% YELLOW

20% CYAN / 5% MAGENTA / 5% YELLOW

5% CYAN / 5% MAGENTA / 5% YELLOW

The entire sequence shows the effects of
Cyan and Yellow as toned down by a 5% Ma-
genta. The sequence presents a very subtle
range of colors, none quite escaping the
cooling-down effect of Cyan. Excellent
Springtime colors which contrast the lighter
and darker shades of adjacent hues.

Typography, Color & Design

100% CYAN / 5% MAGENTA / 20% YELLOW

80% CYAN / 5% MAGENTA / 20% YELLOW

60% CYAN / 5% MAGENTA / 20% YELLOW

40% CYAN / 5% MAGENTA / 20% YELLOW

20% CYAN / 5% MAGENTA / 20% YELLOW

5% CYAN / 5% MAGENTA / 20% YELLOW

This sandy beige background overprinted in turquoise, seems to invite the mind on a Caribbean cruise.

100% CYAN / 5% MAGENTA / 40% YELLOW

80% CYAN / 5% MAGENTA / 40% YELLOW

60% CYAN / 5% MAGENTA / 40% YELLOW

40% CYAN / 5% MAGENTA / 40% YELLOW

20% CYAN / 5% MAGENTA / 40% YELLOW

5% CYAN / 5% MAGENTA / 40% YELLOW

Typography, Color & Design

100% CYAN / 5% MAGENTA / 60% YELLOW

80% CYAN / 5% MAGENTA / 60% YELLOW

60% CYAN / 5% MAGENTA / 60% YELLOW

40% CYAN / 5% MAGENTA / 60% YELLOW

20% CYAN / 5% MAGENTA / 60% YELLOW

5% CYAN / 5% MAGENTA / 60% YELLOW

The Lincoln green background and bright, somewhat muted yellow headline create a sense of discovering a forest clearing on a bright summer morning.

100% CYAN / 5% MAGENTA / 80% YELLOW

80% CYAN / 5% MAGENTA / 80% YELLOW

60% CYAN / 5% MAGENTA / 80% YELLOW

40% CYAN / 5% MAGENTA / 80% YELLOW

20% CYAN / 5% MAGENTA / 80% YELLOW

5% CYAN / 5% MAGENTA / 80% YELLOW

Typography, Color & Design

100% CYAN / 5% MAGENTA / 100% YELLOW

80% CYAN / 5% MAGENTA / 100% YELLOW

60% CYAN / 5% MAGENTA / 100% YELLOW

40% CYAN / 5% MAGENTA / 100% YELLOW

20% CYAN / 5% MAGENTA / 100% YELLOW

5% CYAN / 5% MAGENTA / 100% YELLOW

Here the brightened green takes a positive,
optimistic stand on a ground of slightly shady,
laid-back yellow.

Pages 146 and 147 are a range of neutral gradations, sometimes thought of as "earth colors."

60% CYAN / 60% MAGENTA / 60% YELLOW

50% CYAN / 50% MAGENTA / 50% YELLOW

40% CYAN / 40% MAGENTA / 40% YELLOW

30% CYAN / 30% MAGENTA / 30% YELLOW

20% CYAN / 20% MAGENTA / 20% YELLOW

10% CYAN / 10% MAGENTA / 10% YELLOW

These colors could well be used as background for very light, bright, colored type and dropouts when a quieting effect is desired. Also, they could be used to pull a lot of bright colors together as a unit.

60% CYAN / 60% MAGENTA / 90% YELLOW

50% CYAN / 50% MAGENTA / 80% YELLOW

40% CYAN / 40% MAGENTA / 70% YELLOW

30% CYAN / 30% MAGENTA / 60% YELLOW

20% CYAN / 20% MAGENTA / 50% YELLOW

10% CYAN / 10% MAGENTA / 40% YELLOW

60% MAGENTA / 60% BLACK

50% MAGENTA / 50% BLACK

40% MAGENTA / 40% BLACK

30% MAGENTA / 30% BLACK

20% MAGENTA / 20% BLACK

10% MAGENTA / 10% BLACK

TYPE & COLOR

These are "warm" grays. This series would provide good backgrounds for several different color images on a single page, border tints or added density to a background that won't interfere with the artwork itself. Use them to enhance a grouping by contrasting warm and cool schemes.

5% MAGENTA / 50% BLACK

5% MAGENTA / 40% BLACK

5% MAGENTA / 30% BLACK

5% MAGENTA / 20% BLACK

5% MAGENTA / 10% BLACK

5% MAGENTA / 5% BLACK

60% CYAN / 60% BLACK

50% CYAN / 50% BLACK

40% CYAN / 40% BLACK

30% CYAN / 30% BLACK

20% CYAN / 20% BLACK

10% CYAN / 10% BLACK

TYPE & COLOR

On this page are "cool" grays. Like those on Page 149 these are very classy, understated colors that offer a surprising range of opportunities to make some very attractive combinations.

5% CYAN / 60% BLACK

5% CYAN / 50% BLACK

5% CYAN / 40% BLACK

5% CYAN / 30% BLACK

5% CYAN / 20% BLACK

5% CYAN / 10% BLACK

Naturally, you won't spend all your time putting headlines and text onto smooth backgrounds. These two images, not entirely unusual ones at that, present the opportunity to experiment with trickier backgrounds. While the flamingo park is predominantly green, and the harmonies there shouldn't be hard to find, the stained glass is already a

PHOTO: ALTON COOK

complex set of rules and regulations set to you by another craftsman. In each case, there are extremes of light and dark to deal with, so watch the weight of your type as well as its color. Place overlays on different parts of these images to see what works best where.

This seascape is quite different from the toucan in that there's a tiny point of interest right at the very hard horizon. Let the boat help you capture your reader's interest. Resist all that pretty blue sky, and consider instead running your message over the water, just below the boat. That's where people are going to be looking anyway. The rose, on the other

PHOTO: SKIP GANDY

hand, is evolved to attract attention, and a picture like this could well be your toughest field to play on. Keep your type small, simple and white or perhaps a very dark green. Of course, your message could be one of destruction or evil, in which case you may have to give this beautiful flower a typographic mugging to help you tell your story.

These pictures both offer relatively flat areas of blue upon which to place your message. Resist that first impulse, and ask what opportunities each subject presents. The bird's eye is a focal point and his bill acts as an arrow guiding your own eye to the lower right corner. You can come out of the black feathers with almost any typeface and color you like,

PHOTO: SKIP GANDY

ending at the point of the bill with the point of your message. The swamp offers similar possibilities, but take care not to let your message become tangled in the tree branches when there's so much open water and sky to work with. In short, the simpler the composition, the greater your own freedom, and responsibility, to create an interesting effect.

157

Designs
For Marketing No.1:
Primo Angeli

Journey with this premiere graphic designer as he traces the development of his well-known commercial designs—including DHL, TreeSweet, Cambridge, Henry Weinhard beer, California Cooler—from initial client meetings to the finished designs. Packed with more than 300 four-color photographs and accompanied by lively text, this is an essential reference for graphic artists and marketers.

144 pages **ISBN 0-935603-10-7**
$27.95 **Hardcover**

The Guild 4

Since 1985, **The Guild** has served as the most prestigious juried showcase for American craft artists. Now in its fourth edition, **The Guild** presents the work of 400 leading artisans who work in ceramics, wood, stained glass, wrought iron, fibers, tapestry and a variety of other media. Their work is challenging, intriguing and highly varied in design and stylistic approach. The objects are faithfully reproduced in full color, with a minimum of one page devoted to each artist's work.

432 pages **ISBN 0-935603-16-6**
$49.95 **Hardcover**

The Best of
Ad Campaigns!

Presents 30 of the best recent advertising campaigns as selected by the American Association of Advertising Agencies. Up to twelve pages are devoted to each campaign, and they include every subject, from business-to-business to fast food, and services to durable goods.

256 pages **ISBN 0-935603-09-3**
$49.95 **Hardcover**

The Best in Medical
Advertising and Graphics

Four hundred stunning and remarkably ingenious medical ads and illustrations have been brought together in this book. This must-have reference captures, in full-color, the astonishing creativity of a group of graphic arts specialists whose work has never been seen in such entirety. **The Best in Medical Advertising and Graphics** not only displays the exceptional graphic techniques of the industries' top creative talents, but also presents the effort behind the ads. Included is information on advertising goals and strategies, design objectives, audience targeting and client's restrictions.

256 pages **ISBN 0-935603-20-4**
$49.95 **Hardcover**

Best of Screen Printing

This first major book devoted to the graphic rather than functional aspects of screen printing captures the elegance and utility of this important art form. The book contains superb screen print designs of limited edition art, garments, textiles, vinyl goods and posters, all reproduced in vibrant color. Each illustration is accompanied by information on design strategy, marketing and technical details.

256 pages **ISBN 0-935603-17-4**
$49.95 **Hardcover**
Publication date: September, 1989

Color Harmony

A step-by-step guide to choosing and combining colors, **Color Harmony** includes 1,662 individual color combinations; dozens of full-color photos to show you how your color schemes will look; a four-color conversion chart; 61 full-size color charts and much more.

158 pages ISBN 0-935603-06-9
$15.95 Softcover

Color SourceBook I

Originally published with great success in Japan, **Color SourceBook** I is a treasure trove of ideas for creating color combinations, shapes and patterns. Color concepts under the headings 'Natural', 'Oriental', and 'High-Tech' provide interesting and useful color design combinations to help create an appropriate color framework for the designer to work within. Instructions are specific, geared toward the professional, yet clear enough to be useful to the student.

112 pages ISBN 0-935603-28-X
$15.95 Softcover

Color SourceBook II

Today color and design go hand in hand, and for this reason **Color SourceBook II** is an indispensable tool for creating color combinations, shapes and patterns. This second essential volume furnishes the designer with color concepts under the headings 'Pop' 'Retro-Modern' and 'Post Modern', and creates color and design fields for the designer to work within.

112 pages ISBN 0-935603-29
$15.95 Softcover

noAH III
Directory of International Package Design

Covering the best new work of over 70 top ranked package design studios from more than 20 countries, **noAH III** is a stunning and comprehensive collection of the most unique and visually exciting corporate and brand packaging concepts. More than 1000 full-color photographs are accompanied by essays on each firms philosophy, history and operations strategies as well as address, telephone and fax number.

464 pages ISBN 4-931154-13-1
$89.95 Hardcover

Volume One:
Trademarks & Symbols Of The World
The Alphabet in Design

This wonderful resource and idea book presents more than 1,700 contemporary designs from a variety of sources for every letter of the alphabet. An essential resource for anyone involved in typography, sign and logo design and creating corporate identities.

192 pages ISBN 4-7601-0451-8
$24.95 Softcover

Volume Two:
Trademarks & Symbols of the World
Design Elements

If you design packages, ads, corporate logos, or signage, you must have this resource guide in your design library. It features more than 1,700 design elements that can add pizzazz to any printed piece.

192 pages ISBN 4-7601-0450-X